Colours of The Soul®

Colours of The Soul®

*Transform Your Life
through Colour Therapy*

June McLeod

BOOKS

Winchester, U.K.
New York, U.S.A.

First published by O Books, 2006
Reprinted 2007
O Books is an imprint of John Hunt Publishing Ltd.,
The Bothy, Deershot Lodge, Park Lane, Ropley, Hants, SO24 0BE, UK
office1@o-books.net
www.o-books.net

Distribution in:

UK and Europe
Orca Book Services
orders@orcabookservices.co.uk
Tel: 01202 665432
Fax: 01202 666219 Int. code (44)

New Zealand
Peaceful Living
books@peaceful-living.co.nz
Tel: 64 7 57 18105
Fax: 64 7 57 18513

USA and Canada
NBN
custserv@nbnbooks.com
Tel: 1 800 462 6420
Fax: 1 800 338 4550

Singapore
STP
davidbuckland@tlp.com.sg
Tel: 65 6276
Fax: 65 6276 7119

Australia
Brumby Books
sales@brumbybooks.com
Tel: 61 3 9761 5535
Fax: 61 3 9761 7095

South Africa
Alternative Books
altbook@peterhyde.co.za
Tel: 021 447 5300
Fax: 021 447 1430

Text copyright June Mcleod 2006

Design: Jim Weaver

ISBN-13: 978 1 905047 25 3
ISBN-10: 1 905047 25 8

A CIP catalogue record for this book is available from the British Library.

Printed in the UK by Ashford Colour Press

Acknowledgements

Thanks to my dear family, friends and teachers, both seen and unseen, for their endless love, support and guidance.

Contents

Foreword

For most of us, transformation is not a bolt of lightning that leaves us changed for ever in a space of a few minutes or hours. Rather it is a slow, stable process that takes place over a period of time and brings us up against all manner of seemingly insurmountable obstacles, big and small, until we are ripened and ready to make that big step forward that offers us no U-turns.

Mostly we cannot do this alone, and in his/her wisdom God gives us a situation or a person who acts as a catalyst and a guide through the turmoil of that change. June McLeod appeared in my life as that gift from spirit, whom I could instinctively trust and whose gentle, knowing hand pushed me in the only direction I could possibly go, knowing better than I that it was the only way forward. Her warmth and wisdom have never failed and her guidance has been faultless. During the years of studying colour with her, I discovered that real learning is not just a question of logical application but a surrender of the heart that pushes mental boundaries to their limits and opens the way for the true soul knowledge to assert itself.

It is one thing to teach and another to inspire, and June's approach is wholly inspirational. She empowers her students to acknowledge the latent depth of their own wellspring of knowledge and take responsibility for the application of its power.

Her work is in a class of its own.

S. James, 1999
Colour Therapist Dip. Col. T.S.

Introduction

My own journey into colour began many years ago. I now work as a colour consultant, colour healer and teach the subject I am so passionate about. My students come from all walks of life: some are looking for a new career path, for instance someone from a traditional occupation like banking may decide to learn about colour before taking the plunge in a new direction; therapists enrol so that they can include colour therapy in their own practice as colour can be used successfully with every other known complementary therapy; artists and interior designers are all keen to add the deeper aspects of colour therapy to their knowledge base; others are interested in the subject purely to help themselves and their families; and nursery nurses and teachers want to use the information to help the children in their care.

My colour consultancy work has also had an impact in the high street by bringing the benefits of colour psychology to a wide range of products. Crown, the paint manufacturer, asked me to be part of their colour-therapy endorsement in the UK. By appearing on the shelves in thousands of outlets nationwide, it helped bring colour therapy to the attention of the public.

Colour therapy is a field that is rapidly growing in importance and acceptance; demand for colour therapists is outstripping supply and many more qualified colour therapists are needed to service this need. Although colour therapy has become the latest trend, it is, however, an ancient therapy and has been with us since the big bang – 'and then there was light'. Colour therapy has changed, expanded and developed

over time to mirror our own development and expansion. As our consciousness has changed, so has our use of colour therapy. Colour is now creating a new explosion, the likes of which we have not seen before, and people everywhere are asking how colour therapy can work for them. What is it? What can it do for me? Is it real? How do I harness it? *Colours of the Soul* starts with the beginner in mind and expands to show different ways of using and experiencing colour in your life. Gaining a full understanding of colour and how it affects you will present you with a key that unlocks the treasures that are your birthright.

In this book I aim to show how you can apply the knowledge of colour to help every problem, whether it be physical, emotional, mental or spiritual. I have included a wide variety of examples to demonstrate the benefits of colour in real-life situations. Also scattered throughout the book are many case histories from my own client base – from these you can share in the experience I have gleaned from years of hands-on practice. You will also find details of practical exercises that I use in my colour courses. These can be used by therapists, workshop leaders and by you at home. The book comes with a selection of colour cards that you can use for divining, healing and guidance. And at the back of the book you will find a colour index that you can refer to at any time for further insight into the colours.

If you are searching on life's path and haven't explored colour therapy before, I hope this book will give you much food for thought.

Opening to Colour

*Colour goes beyond words and visual
impact. It is a universal language to be
felt with the heart, fully absorbed and
deeply experienced!*

JUNE McLEOD

The world around us is a glorious kaleidoscope of colour. Imagine for a moment some lush green grass, soft and fresh to the touch and uplifting to the soul. Blueberries and raspberries, blackbirds, red peppers, green apples, traffic lights, goldfish, green hedgerows, golden sand dunes and turquoise lagoons, roses in bloom, snow flakes, Christmas lights, acorns, butterflies and swirling red and white barbers' signs. Picture the glorious yellow of daffodils heralding springtime, the shimmers of sunlight through the trees, rainbows in the sky and the shadows of evening seen through purple and pink sunsets.

Colour is visual. It is everywhere and bombards our senses. It evokes memories, feelings, impressions, tastes, sounds and emotions. It stimulates our mind, body and spirit. We see it, feel it, breathe it, wear it, smell it, eat it, sing it, paint it, write it … we are it. Wherever you go, whatever you do, wherever you look, you are immersed in the existence of colour.

Close your eyes for a moment and watch what emerges from the apparent darkness. The Native Americans knew that out of the blackness comes light and colour, and declared black to be the colour of intuition and new beginnings. Allow your inner world to expand and open, revealing a multitude of colours, feelings, symbols, sensations and impressions. Colour is the stimulus that enables us to see the threads running through our lives and the power within us to change our lives and ourselves into whatever we want.

Colour is the missing link that connects us to all that is and to our limitless potential. By utilising all that colour has to offer us, we begin to consciously understand and tap into the unseen levels and aspects of ourselves. This process raises our consciousness, opening and expanding our minds to levels beyond our wildest dreams and revealing to us our purpose on this earth. It is real and available to each and every one of us. The perfect simplicity yet profound impact of colour opens our minds to enlightenment. It gives us an objective overview of life so that we can see the interrelatedness and interconnectedness of all things.

Looking to nature we see the natural order that we humans have been moving further and further away from in our attempts to control and direct our world. We see ourselves as separate beings when in reality we are part of a coherent whole. Our task is to establish this natural order within us, our lives and therefore the greater whole. To do this we do not have to look outside of ourselves because everything we need is already within, waiting to be accessed, rediscovered and used.

So what exactly can colour do? Quite simply, colour re-establishes confidence and willpower, it strengthens our minds, bodies and inner resolve, it opens us to spontaneity, love, laughter and deep inner happiness. It releases the restrictions that we unconsciously place on ourselves. Colour reconnects us to the earth; it warms and protects us, helping us to feel secure and loved within ourselves. It releases resentment, fear, anger, frustration, pride, despondency, self-pity, depression and the past – stimulating us to take back our power and acknowledge our wisdom.

Colour clears our mind to see our options and helps us make the right decisions based on good judgement and right discernment. It brings a depth of understanding and peace that is deeper than the

deepest ocean and gives us the direction and ability to heal ourselves. Why do you have a headache? Why have you got the flu again? Why are your bowels creaking under the strain? Why do your muscles ache? And why do you feel listless and lacking in vibrancy and energy? Colour knows ... you know. Colour gives us the freedom we all desire and the power to express ourselves in the way we wish to be heard. It brings peace, harmony and balance back into our ourselves, our lives, the workplace and our homes. All this is obtainable and much more. I ask you to suspend your judgement, feel with your heart and allow all that is contained within this book to take you on a journey, a colourful journey, back to the beginning, back to yourself.

The world is rich with colour, it is everywhere and in all things and yet it is overlooked and taken for granted, and the deeper significance and effect that colour and natural light has on us passes us by. When we are blessed with the gift of sight, we have the ability to effortlessly perceive the different colours that permeate our world. This, however, can be a subtle restriction that makes us reliant on what we see, rather than what we feel, and holds us back from taking the time to really *experience* colour. A sunset that is filled with the hues of red, gold and orange is visually stunning as its colours shift and turn as the sun goes down; but what do those colours stimulate in you as you watch them change? How does that experience make you feel? What thoughts go through your mind and what emotions do they bring up? The following case history illustrates the transformative effect that colour has and the impact it can have on our lives if we are willing to set aside what we know and just be open to feel.

Janice releases emotion – with Orange

We absorb the energy of colour through the eyes and skin. However, the energy of colour is so strong that even blind people can sense or feel its vibration and intensity with their hands. Janice is nine years old and attends a centre for blind children. Blind since birth, these children have developed a greater sense of touch, taste, hearing and smell to compensate for their lack of sight. I have been working with these children for some time, introducing them to the world of colour. They can identify cool or warm colours through their feelings. At the beginning of one particular session, I laid out several silk scarves of the seven colours

of the spectrum around the room. The children were asked to go and feel the different scarves and choose their favourite to hold for a while. Janice chose the orange scarf but when the time came to exchange the scarves with one another, Janice would not let go of hers.

Whilst the other children were familiarising themselves with their new colour choice and feeling the difference between the colours and sensations, Janice continued to cling to her orange scarf and wouldn't part with it for anyone. As the session was about to close, Janice started to talk to me about her aunt who had recently passed away. All of this was new to me, but I noticed the assistants watching with amazement and relief as Janice cried and talked about how much she missed her aunt. It had been two months since her aunt's death, but Janice hadn't spoken a word about her during that time. Her parents, teachers and therapists had been very concerned at her lack of expression as they knew she was holding in her emotions and that it could cause her emotional damage the more time went on.

Janice's inner knowing of what see needed to feel went beyond the rational mind and sight into her unconscious mind and world of feeling. As she absorbed the colour orange, it gently unlocked the doors that were holding back the pain so that she could release it.

Colour does not have to be seen to affect us – every cell in the body is light-sensitive and responds to the vibration of colour. It is through experiences such as Janice's and many others that I have developed a profound respect for colour therapy and feel in awe of the beauty, simplicity and transformative power of it. No one is immune to colour – it reaches deep into our psyche, developing our awareness of ourselves and others, the world and the universe as a whole. As a therapy, way of life and universal language, colour therapy has been used and taught in its many forms throughout the ages, affecting each individual and reflecting the state of consciousness of the time. Whilst I will be quoting past masters of colour therapy whose work is relevant to the present use of colour, I will not be going into the history of colour as there are many excellent reference books on the subject. My prime objective is the here and now, taking you forward to experience the world of colour therapy for yourself.

Key to colour cards

1. Red
2. Orange
3. Yellow
4. Green
5. Sky blue
6. Indigo

7. Violet
8. Pink
9. Magenta
10. White
11. Black
12. Pale violet

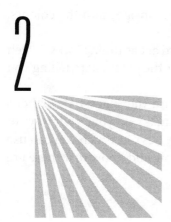

2

The Colour Cards

Colour therapy stimulates our imagination and awakens our innate ability to work with colour – not to intellectualise it, but to feel, sense and understand its effects on our being. These effects are powerful beyond words and, for each of us, a deeply personal experience. The colour cards that accompany this book are a way for you to experience the profound healing and divining power of colour and its ability to change your life. You will find a complete set of colour cards in this book. You will need to cut these out and mount them on cards.

The colour cards will enable your inner wisdom to be heard. Each time you make a selection, your choice will reflect an important aspect of your life at that precise moment in time. The colours you choose will touch the appropriate levels of your being and open your awareness to the colour qualities that you need to work with, thus releasing blockages.

All of the cards are specific colours and circular in shape. All energy and all life originated from and through the circle. Planet Earth is circular and all life moves in circles and cycles. Conscious awareness of this circular process, combined with colour, triggers a

profound soul response, activating a deeper insight into the colours, healing and transformation.

The key words given for each colour card act as tuning forks. Listen to your response to each colour, hear what the colours are telling you and always follow what feels right for you.

After you have familiarised yourself with the suggested methods of how to use the cards, you can begin to make up your own ways of working with them. There is no limit to the ways in which you can use them. Simply allow your imagination to flow and know that there are endless possibilities.

Using the colour cards

Following are some suggestions for how to use the cards. But before you use the cards, go within and spend a few quiet moments holding them in your hands and ask the divine management that you be guided for your highest good.

- Spread the colour cards out colour-side up. Scan the colours and then quickly pick up your first choice. Your first colour choice is your soul response, a recognition at the deepest level. Trust the outcome. Work with the appropriate qualities of your colour choice. Refer to the following interpretations of the colour cards or to the many colour meanings throughout the book. You may want to choose one of the colour affirmations (see pages 68–70).

- Hold the cards in your hands, ask the divine management that you be guided and make your choice without looking at the colours. You may also ask any question before choosing your colour card. The colour you choose will hold the answer to your question.

- Pick a colour card, look at the key words for that colour card, choose one that you feel drawn to and hold that word for the day. The key word you choose holds the 'key' to a current problem within your life, i.e. if you choose the red card and perseverance as the key word, do you need to persevere with something in your life at the moment? Your choice is urging you to persevere, telling you that the end is in sight and that with a little more effort you can make that last stretch to the finishing line. Use your inner wisdom to interpret the key word or words given for each colour card.

- You may need colour guidance for a friend or loved one. Hold that

thought and ask to be guided for their highest good. Then, with your eyes shut, make your selection from the cards held in your hands. Once you have made your selection you can visualise your loved one in that colour, seeing them happy and well. Use your mind to direct the colour to them, send flowers, a plant or crystal in the appropriate colour, or use any other way you can to help bring the colour into their awareness for their specific need.

- This is an exercise for rebalancing. Lay the cards out colour-side up and then choose one colour card. Refer to the information on complementary colours on pages 41–42 and then take the complementary colour card that corresponds to the colour you have chosen. Put the rest of the cards to one side and make yourself comfortable, loosening any belts or tight clothing and ensuring that you won't be disturbed. Spend a few minutes looking into the colour centre of your first choice and breathe evenly and deeply, imagining on every in-breath that you are breathing the colour into your body. Then, after five minutes, do the same with the complementary colour. When you have finished, close your eyes and totally relax for a few more minutes. Enjoy the experience and take note of what you 'see' with your eyes closed. You may find it helpful to keep a record of your experiences by writing them down in a journal or diary. With practice and time, you will surprise yourself with the feeling of calm and serenity you experience and what you 'see' in your mind's eye.

- To let go of discomfort and pain, sit comfortably and quietly, making sure that you won't be disturbed. Spend a few minutes scanning your body for discomfort or pain and making a mental note of where these places are. Once the body scan has been completed, make your colour card choice and then take the complementary colour card from the pack, putting the remaining cards to one side. Look into the centre of the first colour card and breathe deeply and evenly. As you breathe in, imagine the colour going directly to the place of discomfort and gently easing it. Feel your body totally relax and let go of all pain and discomfort on every out-breath. Stay focused on the first colour for ten minutes and then take the complementary colour card and repeat the process for the same length of time.

- For divining and guidance lay the cards out colour-side up. Scan the colour cards, then select your colour. Find your chosen colour in the following list and read the colour interpretation. The card interpretations can be used with the karmagraph too (see Chapter 11).

Colour card interpretations

Red

Key words: courage, perseverance, passion, survival, attention.
An adventurer, a born nomad, you are passionate about all things but you must be careful to use your passion positively, or you can become overly forceful or dogmatic. Issues exist around your energy at the moment. Do you have too much? Are you restless? Or, do you feel drained, dull and exhausted, in need of a boost? You have the strength and courage to draw upon to make the necessary changes. You are in your element in the role of leader. You're not afraid to take the initiative, but you may be unwilling to delegate, believing that you're the only one who can do something correctly. Doing everything yourself can lead to frustration, resentment and a weakening of your energies, leaving you feeling depleted, stressed and tired.

Watch your health. Take a good liquid supplement for a quick short-term boost if you are beginning to feel the strain. One way to avoid getting too fragmented is to focus on one or two things and specialise in those areas, rather than diversifying too much and becoming a 'jack of all trades and master of none'.

You love excitement: this can sometimes make you act rashly, without carefully thinking through the consequences of your actions. Caution is needed, red. Every action has a reaction.

Always follow your heart and direct your energies wisely and carefully into worthwhile pursuits that you know you will be able to complete. You are a born romantic and you love deeply and passionately. You seek the security of a long-term, committed relationship – a stable, deep, loving relationship is of utmost importance for you. This is an area where you can learn a lot about yourself, as others will provide a perfect mirror and serve as a catalyst for your growth. Always bear this in mind with any family issue you need to look at.

You need change, movement and variety in your life and you become a restless spirit if you feel stuck in any area of your life. An office based nine-to-five job would be unsuitable for you. By the same token, you have unlimited drive and energy for all that you are interested in and you love to be seen, noticed and acknowledged for

your work. Knowing yourself and what you really want out of life is especially important for you as you can wear different masks and be different things to different people. Remember the maxim 'to thine own self be true'. It's important to find a balance and recognise that it's not always the situation you find yourself in that needs to be changed, but the way in which you perceive it.

Be aware of any control issues that you may have, as you can easily use your strong will to dominate or manipulate others.

Channel your tremendous vitality into realising your highest goals and be ready to fulfil your life's purpose. You have infinite possibilities to make a quantum leap in your life at this time and to experience a joy and freedom beyond your wildest dreams. It is never too late to start a new venture, to realise your dreams and to fulfil your life's purpose, but don't forget that it's important to complete whatever you start, red. You are a great starter, but your enthusiasm can fizzle out just before the finishing line! Build trust in yourself and dare to JUST DO IT!

Orange

Key words: enthusiasm, fun, health, wide interests, humour.
Anything too serious and heavy now will take you into the doldrums and oppress this wonderful, light, effervescent energy. 'Always look on the bright side of life' goes the song and this is important for you to remember at this time. Your happiness and that of others is now paramount. This is not the time to take anything too seriously, or allow your spirits to be dampened. Look on the bright side, keep smiling and remember that laughter is the best medicine – it will literally boost your immune system. Orange is a wonderful antidote for depression, loneliness and tiredness. Fun is the key word for you. When you are having fun, then you have found your forte and you are being yourself. Develop your natural outgoing personality, go out more and enjoy yourself, acknowledge and then release your insecurities.

Keep an eye, orange, on your nutrition and make sure you feed yourself correctly. Food is fuel and you need the very best quality if you are to be at your optimum. That doesn't mean to say, however, that you cannot indulge in the occasional treat! See yourself brimming with health and happiness and live life to the full. You love life and

all that it has to offer – enjoy it, decide what you want and go for it. Remember that only you can stop yourself from achieving and it's time to be aware of any barriers that are holding you back. These barriers may be self-imposed or come from early conditioning – but, whatever their origin, you need to break through them and release any deep feelings and hurts that you may have.

It's time to discover your creativity – what would you like to do for fun? Bring lightness and play into your life and work and you will be one very happy bunny. Visualise yourself bursting with happiness and laughter and be aware of your wholeness. Don't be the tragic clown but rather learn to share your deeper feelings and hurts. This you find hard but an excellent way for you to release and let go is to write down all your innermost thoughts – for your eyes only – then burn the paper. Just get it out on to paper, then let it go. Don't hold on, orange.

Be at ease and be well and keep a smile on your face. Others feel good in your company as you lighten the atmosphere and can see the funny side of any situation. Allow your natural radiance to shine, you deserve and owe it to yourself and others to shine and share your lovely and unique outlook on the world.

Yellow

Key words: clarity, discernment, confidence, awareness, broad-mindedness.
You are being asked to accept that, in spite of the fact that you have a good mind, you are not always right. You have a strong ego, but bear in mind that knowledge that comes from the intellect can sometimes distance us from our experience and give us a false perspective. Always searching and discovering, you can sometimes lose your direction by trying to learn everything, yesterday. Listen to and take on board suggestions from others in your immediate circle of family and close friends. They can give you the clear and balanced overview that you at times can't see. They do have your interests at heart. At the same time, be aware that endlessly searching outside of yourself for knowledge prevents you from connecting to your inner voice and your innate source of wisdom and guidance.

Your inner world and your spirituality are the most important areas of study for you to springboard from, yellow. Inner reflection,

visualisation and meditation are all wonderful ways for you to bring yourself back to the beginning, and the beginning is you.

Stop analysing and begin to feel and sense, re-learn this true wisdom and allow your light to shine forth. Trust in the divine management and know that there is a greater power than us at play. We cannot have total control over our lives; real inner peace comes when we do our best in any given situation. Work with the highest intent in everything you do, then you must let go, and trust that the outcome will be for your highest good. Your needs will always be met, you will always receive what you *need* for your soul growth, not necessarily what you *want*.

You assimilate facts well. You have a sponge-like capacity to absorb information, although you are not necessarily an academic. The butterfly of the spectrum, you flit from one activity to another, from person to person, group to group. Enjoy landing for a while, yellow!

Appearances are important to you and you like everything to be and look good. You make an impact at any social event, you love to dress to suit the occasion and be noticed. People remember you. Few people, therefore, know who you really are as you only give them what you want them to know. Remember, however, that the impact you make on people has much more to do with who you are. Reflect on what it means to be who you are and ask yourself if others truly see the real you. Be aware of any emotions you put aside or block off and how much of yourself you keep hidden. Allow others to see more of the real you, rather than what you choose to show them.

Develop your writing skills. You are able to relay information to others easily and effortlessly. Develop your expertise and use your organisational skills to assist you in collating the information you need for future use. Keep your home and your workplace clear and free of clutter and regularly clear out unused and unwanted papers and belongings. This will ensure that you have the right environment to work in.

You have a bright, inventive mind, brimming with good ideas. Pursue new ideas and know that they are worthwhile and will be accepted. When you communicate what you believe, it will be as if a light is switched on in people's minds. Push back the boundaries in your life and see the open space in front of you. Create your own vision for your future, for the time is near for you to reach the pinnacle

of your chosen path. Be proud of your achievements to date, and give yourself a well-deserved pat on the back.

Green

Key words: harmony, compassion, equilibrium, heart, space.
If the colour green is your choice, a change of scenery is needed to rejuvenate your spirit and give you a fresh outlook. Give yourself some space otherwise you could become depleted and overstretched.

Your warm and open-hearted nature makes people feel very comfortable and relaxed around you and in your home. Your home is your castle, and a bustling hive of activity. You are wonderful company, and have the ability to make others feel at home. You are the host/ess with the most/est. You will be the first port of call for many for good food, good wine and good company. You like having a lovely home and collecting beautiful things, especially antiques. You love animals and children, the more the merrier! Your door is always open and you love people to drop in.

You're a natural humanitarian. Get involved in groups or activities that are personally meaningful to you. Environmental bodies and animal groups reflect the kind of concerns you have and it's important that you recognise your ability to make a difference and instigate many positive changes in the world. Put your ideas into practice and watch them come to fruition. Peace is important to you and you are an excellent mediator and peacemaker as you are able to see all sides of any situation.

Don't underestimate your talent as an entrepreneur, green. You have a good business mind with a solid insight into others' needs; you can see the 'gaps' in the market. Mind you don't take on more than you can deal with though, as ventures will flourish quickly with your ability to attract 'green' money. Contrary to tradition, green is a lucky colour and attracts abundance.

You feel at ease and at peace in nature; the sight of natural beauty will make your heart sing. You are definitely a country person, not a townie. Use your green fingers and grow your own flowers, herbs and vegetables. Begin with pots and then gradually explore the garden. Nurturing this side of yourself will be very therapeutic.

You need to give yourself time-out regularly – take yourself off for a

few days and just be. A pampering style weekend would be marvellous for you, green; you are geared to give, therefore you need to replenish. Receiving massage and body treats would help you to restore your equilibrium.

Personal growth is very important to you, whether it be yours or other people's, and you're always evolving and stretching your mind. You also have the capacity to support others in their own development. Even when you grow older you retain the qualities of eternal youth, keeping a young mind, and seeing the magic in everything. You're open to new beginnings and you need the freedom to explore different ways of doing things.

Practical and down-to-earth, you don't like to throw food or anything else away. Balls of string, tins of odd buttons, old magazine articles – maybe you're just a tad of a hoarder, green? You will strive to recycle as much as possible or re-use things in innovative ways, you can't bear waste.

Sky Blue

Key words: healing, trust, loyalty, peace, communication.
You are a restful and supportive soul and, at this moment in your life, you long to do something worthwhile and to find a new direction. By drawing this card you are being given a gentle cosmic nudge. You know what it is you want to do and should be doing. Is it your unselfish nature that is preventing you from taking the first step? You don't like to let anyone down, yet aren't you failing yourself if you do not make the necessary changes in your own life now? Those who love you will understand your need to take a new direction at this time. Be direct and open in all your communications with loved ones and discuss all the options. Let them know how important it is for you to move forward. Once they fully understand they can then feel part of the changes and offer you the support you need at this time.

Be careful, however, not to overtax your finely tuned energies as you have a tendency to be something of a workaholic. Your giving and loving nature has a wonderful healing effect on others but unless you allow yourself to receive, you can often end up feeling lonely. Peace reigns in your presence and others feel uplifted by you. Your innate ability to make others feel better is loved and appreciated by all who come into your orbit.

Express your sensitive and highly intuitive nature and speak up and out sky blue. Never presume that others know what you know to be true. You are now aspiring to true knowing which has been learnt through many incarnations.

Sky blue is known as the greatest healing colour of the spectrum and is the gateway to heaven. You are the communicator between heaven and earth and like the deep blue of a lagoon, your depth is limitless. You are naturally intuitive and you can now expand and develop this side of yourself. Listen to your inner voice of the heart at all times, as it will guide you. If conditions and circumstances are right and correct for your soul growth, nothing can stop them from coming to you. What is yours by divine right is yours, and all will flow easily and effortlessly. You will know when something is not right, as barriers will be put in your way and your goals become very difficult to achieve. When this happens, stand, be still, go within and seek direction. At every crossroads in your life, go within, link with the highest spiritual source and as for direction. 'Thy will, not mine.'

You have experienced much so far in your life and you can now positively help and assist others on their journey, by uplifting and inspiring them with your natural sensitivity and the courage of your convictions. You love to be actively involved in your local community.

You are the communicator of the spectrum and the liveliest of the blues. You are a natural orator and, like sparkling water, your words have a clearing and cleansing effect on others. Always think about what you say as words contain energies that are released when we utter them. Sky blue is the communication bridge between the physical and spiritual planes. With your unique, witty and wonderful creative expression, you can bring peace and harmony to many within the growing movement of self-development. Others love to listen to you as the tone and quality of your voice has a calming effect on the nervous system.

Have you ever considered joining a speaking circle? Even though you may initially pull back from this suggestion, the seed has been planted and your thought processes will bring the idea forward when it is appropriate. When that happens you will be gently nudged in that direction. You are an excellent leader, you are able to boost morale and build team spirit. You can also encourage others to be

provocative and give of their best for the good of the group. Always remember to use your undoubted powers of persuasion with wisdom. Your open-mindedness means that you are always searching for 'new' knowledge.

Major changes are on the horizon for you, sky blue. Everything in your life has a meaning and you will know what it is you're meant to be doing. Your soul's purpose will let itself be known in the precious and quiet times of stillness. Just listen to your own inner whispers. Stay open to the vast ocean of energy that flows through you and connects you to everything around you.

Indigo

Key words: seeker of truth, reformer, idealist, knowledge, teacher.
Your gift is your ability to earth the pure knowledge and communicate it in such a way that everyone understands its true simplicity. As a teacher of the esoteric truths, you are able to bring this knowledge from a higher level so that others can receive it. You understand that to give and receive graciously is balanced. So much of your time is spent day-dreaming in other realms that your insight and intuition have become highly developed. By connecting daily with the higher energies so much information will be available to you. Always keep a diary or tape recorder handy to keep a record of your innermost thoughts. Ask to be taken to the halls of learning each night before you go to sleep. You will be given all that you need to know to guide you forward, either in your dreams or waking moments.

Your instinctively know midnight is a wonderful time for you to sit quietly and put your thoughts on to paper. Before you start, spend a few moments with your eyes closed, attuning yourself to the highest spiritual realms. Ask to be guided and then begin writing; your inspiration will flow. Your highly attuned intuitive knowing and awareness has been earned and you truly understand the truth – 'spiritual truths are earned, never learned'. Putting that knowledge into practice, day by day, has brought you to this place.

There is no need for this to be a lonely path, indigo. If you ask and hold out one hand, you will be surprised at how many will respond. You have a long list of people you can pull in to help at a moment's notice. They are waiting in the wings and will be only too glad to

help. You will be truly pleased at just how much support and advice is readily available now.

Keep an eye on your diet and try to exercise more – your circulation is sluggish and needs a kick start. You must set limits on your time spent helping others. You are a marvellous unpaid counsellor, indigo.

Remember to breathe correctly too, as breath is the ultimate link to life itself. Use your abundance of potential, indigo, and spiral ever upwards. The sky is the limit.

Violet

Key words: stillness, inspiration, spirituality, sacrifice, high ideals.
Now is the time to recognise that you are gifted and open to success. Others aspire to be at your level and you are able to awaken a greater understanding in them. Recognise this within yourself and see the positive changes that you bring to people's lives. You are dedicated to your work and all that you undertake will be done well. You teach by example and you can easily motivate others to bring about changes in their lives. Always living within your own spiritual code, you feel at home when you link to the highest realms for ideas and inspiration.

Never fear your own success, violet. You were destined to make your mark. Your time is now and you owe it to yourself to be all that you can be. You are a combination of blue, the soul's purpose and red, persistence. Leave the side road, violet, and head for the motorway. Let that grin spread to a full beam, and enjoy your journey. The world truly is your oyster.

Service of the highest order is your truest path, so go forward in trust and faith. Try not to become frustrated with your efforts and trust that your first thoughts and ideas will be the best. Go with them and don't allow your striving for perfection to stop you from completing your tasks. Your best is more than adequate, violet. By trying to change what comes to you, and making it better in some way, you often lose that first spark of your uniqueness. If you stay with your original line of though you will never regret it. Your key is simplicity. Some of the greatest ideas and inventions are the simplest. Losing sight of yourself creates feelings of helplessness and frustration and can lead to melancholy. Slow down, violet, your mind is ever active and your body tires trying to keep up!

You give out so much without even a thought of return, but as we give, so shall we receive – either in thought, word or action. The power of the circle returns to its starting point. Follow your dream, violet, and with your feet on the ground, reach for the stars.

3

The Energy of Colour

A scientific approach to colour

Colour is manifest in all that we see and has always been an essential part of life and our existence on earth. In the 1670s, Sir Isaac Newton scientifically verified the existence of colour within natural light by passing light through a prism, naturally directing the sun's white ray into the seven spectrum colours – red, orange, yellow, green, sky blue, indigo and violet. We can see this clearly through the natural phenomenon of a rainbow, where droplets of water act as a prism and split the white ray into coloured rays.

Newton believed that these were only colours and he overlooked the spiritual aspect of light that had been included in all the advanced works and esoteric teachings of ancient times. With Newton's findings, the study of colour took a scientific turn, moving away from the strong spiritual roots that had previously predominated. A truth cannot be lost forever though and we are now bridging the gap between science and intuition, bringing colour full circle and harnessing not only science and its findings, but most importantly spirituality and

the deeper meaning and effect of colour. All things are a progression of what went before, and many years after the death of Newton, the 18th-century German poet Goethe rediscovered Aristotle's theory that all colours known to man can be derived from one of the four elements – air, earth, fire and water. In fact Goethe wished to be remembered more for his work on colour than for his poetry. One of his main theories was that blue and yellow were the primary colours and that these two colours, as well as black and white, were linked to the four elements. Without the natural light from the sun, the spiritual light that is omnipresent, and the four elements, nothing is able to survive and grow. By taking time out of our busy schedules to walk or sit outside, we absorb these colour rays from natural light – regardless of the weather. The summer months are a joy and we respond to the sun by lightening up and smiling more. It fills us with energy, charging our batteries and preparing us for the winter months when the light is more limited. Winter is traditionally the time of hibernation, relaxing indoors in the warmth and comfort of our homes. However, more and more people are feeling the lack of sunlight and are experiencing lethargy and depression as a result. These feelings make it all the more important to spend as much time outside as possible, absorbing the colour-filled rays.

To gain more of a scientific knowledge of colour, we look to the advances and understanding that science has given us on colour and energy. Science demands that all things are tested, reasoned and proven to reach its criteria of the truth. Science explains colour and light as electronic waves moving at different speeds. The human eye can absorb and is aware of far more than we can actually see. Our eyes can see the visible spectrum known as the rainbow colours. There are also invisible rays that exist on either side of the visible spectrum. Infra-red and radiowaves are present at the red end of the spectrum, and ultraviolet and gamma waves go unseen at the violet end. Colour therapy deals directly with the visible spectrum. Each of the colours has different wavelengths and speeds of movement. The speed at which these waves of light move determines their pattern of flow. Red is the longest wavelength and has the slowest frequency of vibration. The wavelengths then decrease and the speed increases as the reds develop into orange, then yellow. Yellow develops into green, then sky blue into indigo. As the spectrum reaches violet, the wavelengths are

shorter and the vibration is the quickest. All things in the universe move in circles and cycles and colour is a perfect example of this process. The infra-red and ultraviolet rays combine to create magenta – known as the eighth colour in colour therapy – connecting the violet end of the spectrum to the red. A bridge is formed completing the cycle of development.

The aura and chakras – our cloaks of many colours

Everything in life is energy and is sustained by energy. We, like all things in the universe, possess an energy body. Ours is called the aura. The aura is made up from our own personal animations of energy projected through the physical body and energy centres or chakras, and each one has a part to play in our wholeness and wellness. Our aura encircles our physical body. The existence of the human aura has been accepted throughout the ages. We can see art dating back hundreds of years portraying the aura, seen as a halo, around the heads of spiritual figures. The aura can be scientifically proven through measuring the electromagnetic field that constantly surrounds us. The energy that sustains this electromagnetic field is provided by the cosmic energy that is everywhere. The body acts like a prism. As light is drawn into the body, it is split into its coloured rays and these rays are then distributed to the seven main energy centres – the chakras. The chakras provide a constant flow of energy and colour to the layers of the aura. Chakra is a Sanskrit word meaning 'wheel' and chakras can be likened to miniature suns, swirling Catherine wheels or vortexes of energy. The chakras are located within the aura and draw in and put out energy, supplying the body with the life force that sustains us physically, mentally, emotionally and spiritually. There are other minor chakras called secondary chakras – four of these can be found in the hands and feet – one in the centre of each palm and one in the centre underneath each foot.

Colour therapists base their work on the seven colours of the spectrum, which are the colours of the rainbow. Each colour is connected to one of the chakras and each of these coloured centres feeds different parts of the body.

Every bone, liquid, cell, organ and gland in the body has differing

vibrations and wavelengths that relate to and radiate colour. If a person becomes unwell, the vibration/colour of a particular body part drops or increases, creating an imbalance. As the energy of one body part becomes imbalanced, it affects the delicate balance within the body and all things become affected, including the mind energy and emotional energy. This energetic change is reflected in the energy of the chakras and the aura. Through the application of the correct combination of colour, the energy of the chakras and body are brought back into balance and harmony is re-established. As well as having an effect on our energy levels and physical health, the chakras have an effect on our mental, emotional and spiritual health.

COLOUR	CHAKRA	POSITION	AREAS OF INFLUENCE
Red	Base or root	Base of spine	Security issues, grounding, stability, courage, perseverance
Orange	Sacral	Navel area	Gut instincts, emotions, exercise, movement, vitality
Yellow	Solar plexus	2-3in (5-7.5cm) above navel	Intellect, personal power, will, confidence
Green	Heart	Centre of chest	Unconditional love, compassion, forgiveness, understanding
Sky blue	Throat	Centre of Adam's apple	Speech, communication, creative expression, soul realisation
Indigo	Third eye or brow	1 in (2.5cm) above centre of the eyebrows	Concentration, intuition, imagination, insight, clairvoyance
Violet	Crown	Top of the head	Union with higher self, infinite, spirituality, higher consciousness

Each of the seven coloured centres is linked to different levels of our being. The red ray is linked to the physical body and our survival instincts, orange to our feelings, yellow to our thoughts, green is the balancer and harmoniser between our physical and spiritual nature, sky blue is linked to our divine wisdom, indigo to the divine mind, and violet to divine will.

Issues associated with the chakra centres

Red	Our earth connection. When balanced we are able to understand and have the courage to live out our mission and our life's purpose.
Orange	Links to our emotional and sexual responses. When balanced it gives us freedom to express our emotions, our sexual needs and ourselves.
Yellow	Represents our personal power and how we feel about ourselves. How we feel others perceive us and feel about us. How we view our place in the world.
Green	The heart centre, our love centre. When balanced we are able to give and receive unconditional love, we are able to love and nurture ourselves and to accept ourselves, warts and all.
Sky Blue	Our communication centre. Our ability to communicate our needs and requirements. When balanced we are able to recognise when someone or something isn't feeding or nurturing us.
Indigo	Our centre of intuition and higher mind. When balanced it gives us the ability to perceive beyond our five senses. Our consciousness expands and we can then peep into the unknown realms and use these insights in our lives.
Violet	Our spiritual quest in which we desire to experience all that the universe has to offer. Seeking answers to philosophical questions. Our ability to freely discuss our changing beliefs.

Sensing and seeing energy

A simple way to sense the energy in your hands is to rub them together to stimulate the energy flow. Repeatedly bring your palms together without touching, and then draw them slightly and slowly apart for a few seconds. As you do this you will begin to feel the energy building, and if you do this at night with the lights off, you may actually see the energy passing between your palms. The auras and chakras are invisible to normal vision; however, those with heightened awareness can perceive the aura in part or full as a mist of light or a screen of moving and changing colours. These colours reflect our energy levels and state of health, as well as each thought, emotion and imbalance and provide a colourful picture of how we are feeling at any given moment. They are an accurate record of our feelings, thoughts and the condition of our health. The connection between mind, body and emotions is now becoming recognised as well as the fact that **dis-ease** is often caused by our psychological reaction to life events. By using our minds positively and combining colour with breathing exercises, visualisation or affirmations, we can strengthen our auras and bring about positive change within ourselves. This in turn has a positive impact on the conditions around us.

In 1940, a Russian technician named Kirlian pioneered a special type of photography that captures our energy on film. Today we can have a Polaroid photograph taken showing the colours of our aura, and this can be interpreted by a trained therapist. As our auras hold our energy and reflect our state of wellbeing on every level, an aura reading can show imbalances that can lead to physical problems *before* they manifest in our body. The aura is continually changing, moving and pulsating in its free movement. As we grow in awareness, it becomes more possible for us all to see auras. Try this simple exercise.

Seeing auras
• • • • • •

Begin by sitting quietly and looking at a flower. Focus on the flower and allow yourself to look through it. After a while you will begin to see its aura as a hazy light surrounding it. With more practice on flowers, plants, crystals etc, you can begin to practise on people. Your subject should be sitting or standing in front of a white background in natural light but not direct sunlight. Always look through and past your subject, allowing your eyes to focus on the light background. Your first sighting will probably be a shimmery haze of light similar to that which you saw around the flower. With the human aura, the light pulsates more and you should experience more movement. With practice, you will begin to see colours when you are relaxed. Like an unused muscle, your inner sight needs to be retrained to see. Children's auras are so pure and light that it is usually quite easy to see their aura surrounding and dancing around them, especially when they are happily playing. The key is not to try too hard. Stay relaxed and be patient and look through your subject.

We can all sense and feel the energy that another person projects. From their auric field, you can tell if someone is contented, approachable, happy, sad or angry. The aura also acts as a form of protection. If your aura is strong, you are protected from harmful or negative energies that may zap your energy. Awareness of colour and positive thought help to strengthen your aura so that you stand in your own power, radiating positive energy and colour.

Every shade of colour within the auric field corresponds to a certain vibration, indicating a certain mood or emotion, and each has its own meaning. A bride on her special day, lovers embracing, or a mother cradling her baby will radiate a special love glow and a sensitive person will see this glow as a luminous rosy pink within the aura.

When we refer to people as looking at the world through rose-coloured spectacles, they are! When we are wonderfully happy and content, this colours the way in which we experience our lives. Conversely, when someone is bad-tempered and angry, they will 'see' red and deep flashes of dull red can be seen in their aura. Our moods and emotions do not linger and, after a while, shades of colours will dissipate within our auras making room for new shades of feelings. Our auras are continually affecting and influencing everyone we come into

contact with, both positively and negatively. We all know the feeling of our space being invaded when somebody gets too close! In our lowest moments we turn for comfort to those we love and trust and who radiate love and strength from their auras. They help use to retune to a higher vibration that we at times find difficult to achieve alone.

Protecting and strengthening your aura

We can increase, decrease, protect and strengthen our auras with our thoughts, our breath and a few daily exercises that need only take a few minutes. We can work with colour to build and strengthen our aura so that we are radiating our positive, colourful emanations rather than absorbing the energy of everyone else around us.

When preparing to explore the exercises it is necessary to find a warm, comfortable spot where you will not be disturbed. Exercises may be carried out inside or out, sitting or lying, whatever is most comfortable to you. In order to make yourself as relaxed as possible:

• Loosen belts and any tight clothing and remove your shoes.
• Take the phone off the hook.
• Take a long deep breath in and stretch your body as far as it is comfortable, then exhale, relax and go limp.
• Repeat this at least three times.
• Imagine sinking into the surface upon which you are relaxing.
• Regulate your breathing and remember a time when you were standing by the sea.
• Breathe rhythmically as you picture the waves gently lapping in and out.

Now you are ready to try the following exercises.

Encircling yourself in white light

For the ultimate protection and strengthening of your aura, imagine yourself encircled with white light before sleeping at night and at intervals during the day. You can do this by picturing yourself encircled in a white balloon, standing in a column of white light or within a pyramid or circle of light. Go

with whatever you feel most comfortable with. There's no need to struggle to 'see' the white light, simply accept it and know that your aura is protected and strengthened. If using the exercise before sleeping, ask that you be given all the information you need in the sleep state to assist you on your path. Before travelling, whether on public transport, by car or plane, use your imagination and 'see' the transport and all its passengers surrounded by light and ask for the safety and protection of all.

Breathing in colour

You may prefer to breathe in the colour of your choice. As you breathe in, imagine pulling the coloured light down from the cosmos through the top of your head. Imagine a fountain of coloured light showering down and, as you breathe it in, imagine it permeating your being and filling you up from the top of your head to the tips of your toes. As you breathe out, imagine this same coloured light expanding around and from you, creating an egg-shaped shield of colour. While doing this, you could also affirm, 'I give thanks that I am bathed and protected in the light of the highest'.

Each of the seven spectrum colours can be used in this way with white being the ultimate protector. Violet is the greatest purifying, cleansing and purging colour of all and very powerful to use. Follow the same method.

The rainbow breath

The rainbow breath is an all-round balancer for recharging and rebalancing the chakras and by extension the aura. It is preferable to take yourself outside to carry out the exercise. First thing in the morning when the sun is rising is the ideal time. Stand with your feet slightly apart facing the sun with arms hanging loosely and comfortably at your side and palms open towards the sun, so that the minor chakras in each palm can be energised. Close your eyes and breathe in the appropriate colour for each chakra, starting with the red centre. Breathe red in and out for either three or seven breaths, imagining the red centre being flooded with red light. Then move up into the orange centre and so on until you reach the violet centre. When you have completed the rainbow breath, be still for a few moments as you engage in the experience of this rebalancing exercise. This exercise balances and floods the centres with colour and strengthens the aura.

Dealing with negative emotions

We can use our knowledge to benefit others and ourselves. As we apply our knowledge, our connection to the divine worlds becomes stronger and we become 'lighter', radiating beacons of light.

If you find yourself in a negative situation, use the light to surround and protect you. Pink, the colour of unconditional love, can help to disperse any negativity and feelings of anger. If you find yourself in a situation of conflict or confrontation, imagine the other person enclosed in a pink bubble and their anger will dissipate.

May dissolves anger – with Pink

May dreaded coming home in the evenings. Working as a florist meant she was on her feet for most of the day and she needed to relax when she came in from work. Her son Charlie's rude and aggressive behaviour towards her was a blot on the landscape. One evening, as Charlie stood shouting at her, May decided to put into practice her knowledge of pink. She concentrated on the colour, 'seeing' Charlie in a pink cloud. At first it was difficult but she persevered. Charlie visibly calmed, made a dismissive remark and left the room. This was the first time Charlie had retreated. Over the following days and weeks, whenever she had the opportunity, she 'saw' Charlie in pink, the colour of loving acceptance. His anger diminished and one evening for the first time in an age they were able to sit down and talk together. Charlie talked through his fears and discussed outside pressures and May was able to tell Charlie she loved him. We can erase so much pain with the words 'I love you'. Pink benefited them both. May believed her actions told Charlie she loved him. Charlie needed to hear the words 'I love you'.

Therapists can often pick up 'stuff' from their clients. If you are working in this way, you will find it very helpful to cleanse and strengthen your aura as well as your working area with light, before and immediately after each session. It only takes a few moments to cleanse and clear any space with light.

The golden light
• • • • • • • • • •

The golden light is another wonderful colour to work with for emergencies whenever you feel yourself in a negative situation or you need a quick purifier and cleanse. It is a fast way to remedy and cleanse any negativity. On the in-breath imagine golden light pouring through the top of your head, permeating the whole of your being, and it being filled with golden light. On the out-breath imagine this same golden light going straight back out of the top of your head, cleansing and clearing any negativity or energetic baggage you have collected. This need only take a few seconds and can be carried out at anytime and anywhere.

Tools for testing the aura

Following is an exercise that proves our ability to strengthen and protect our aura. We are all able to expand and contract our aura and the use of dowsing rods shows this very clearly.

Using dowsing rods
• • • • • • • • • •

To make your own dowsing rods, all that's needed is a pair of steel coat hangers and a straw. You will need to make two cuts in each hanger. First, cut the long straight base at one end. Make the second cut about 5in (12.5cm) above the angle on the shoulder section at the opposite end of the base. Repeat the process with the other hanger. Next, bend the short sides out at right angles to create two L-shaped wires. Cut the straw to size and slide it on to the short, handle ends. Then hold the straw ends, one in each hand, so that the hangers move freely within the straws and you have no control over their movement. Next, make a connection with your rods and test their signals for 'yes' and 'no', i.e. 'yes' = open wide, 'no' = cross over. Once you have done this, you can test with some simple questions. You are then ready to work with a partner.

One of you stands with your arms relaxed at your side, thinking and imagining that your aura is expanding. As you are focusing your thoughts on this, you are breathing in a relaxed way and imagining that your aura is expanding with every out-breath. The other person, the dowser, walks slowly towards you, pointing the dowsing rods at you. (The dowser does not

have to think of anything other than being definite in their mind about what they are looking for with their rods – in this case the outer fringes of your aura.) As the dowser walks towards you, the rods will at some point either cross or open very wide, showing this to be the outer fringe of your aura. Then repeat the exercise but this time think of your aura as decreasing or shrinking. As you breathe in a relaxed way and imagine your aura decreasing in size, your partner walks towards you with the dowsing rods and again they will cross or open wide to indicate the outer fringe of your aura. On this occasion, it will be a lot closer in than before, showing clearly that the aura has decreased in size.

The uses of dowsing rods are limitless and they are great fun for all ages to experiment with. You can use them to dowse for the chakras on a partner; to confirm the existence of the aura; to choose a colour for activity, rest or relaxation; to discover underground water – whatever you want. If you are a beginner, the best way to begin your investigation into this fascinating way of working is to choose from the natural world of trees, plants, flowers, rocks and crystals. Some trees have amazing auras that are metres wide. An enjoyable family game is to go out into nature and have one family member hide behind a tree whilst the others find them using their dowsing rods.

Using a pendulum

You may also want to experiment with a pendulum. For this you can use anything from a crystal to a button on a piece of thread, provided that it can move and the weight on the end is heavy enough to make the pendulum swing. As with the dowsing rods, check your signals from the pendulum for 'yes' and 'no'. To do this, hold the pendulum in your right hand above your open left palm and ask what the movement for 'yes' is. Wait for the pendulum to move and then repeat the same for 'no'. (These signals can be a clockwise circle, an anticlockwise circle, an upswing, a downswing or a sideways swing. The size of the rotation indicates the strength of the answer.) Whilst some get an immediate response, others may need patience. It may be helpful to give the pendulum a gentle swing to start it off. Once you are satisfied, you can ask the pendulum any question that is easily answered with a 'yes' or 'no'. When asking questions for another, you may find it helpful to place your left hand over the other person's heart centre.

This will give you a stronger response from the pendulum. You do not need to physically touch them, but can hold your left hand a hand's width away from their body directly over their heart.

The key to success with dowsing rods and pendulums is to be definite and clear in what you are asking. As with all light work, before you start always link to the divine dimensions, what I call the management, and ask for divine guidance and illumination. Whether this is for you or another, it is the intent with which you carry out any task that is so very important. If your intent is of the highest before you commence, you can then link easily to the higher realms for 'light' guidance.

The cosmic clock

Ancient esoteric schools recognised and respected the influence of colour on our lives and connected each colour to set times of the day and night, the cosmic clock, the days of the week. By wearing something in the colour of the day, they believed that they were tuning into that particular universal colour ray of the day.

DAY	PLANET	COLOUR
Sunday	Sun	Golden orange
Monday	Moon	Violet
Tuesday	Mars	Red
Wednesday	Mercury	Yellow
Thursday	Jupiter	Sky blue
Friday	Venus	Green
Saturday	Saturn	Indigo

Similarly, when working with colour energies, it is important to be in time with the cosmic clock. As the day progresses, different energies predominate in the atmosphere and subtly influence us in many ways. For example, yellow stimulates us to rise in the morning, fresh, and well rested, and helps us to work with a clear and uncluttered mind. Orange helps our digestive process and stimulates our creativity in the early afternoon. Red brings a feeling of completion and accomplishment as the sun sets. Violet leads us to contemplation of the day and with indigo we relax and clear the mental and emotional

dross of the day. Sky blue connects us with our true potential and purpose for the coming day.

The early part of the day from dawn onwards is the most beneficial and productive time to go outside and do our rainbow breath (see page 29) and other colour breathing exercises. As the sun rises, so do the new energies of the day, gradually increasing as the sun gets higher. After midday, the sun holds its energy before beginning to dip and finally going down as the sun sets.

We are exposed to and being influenced by the cosmic colour rays 24 hours a day, even when there is no daylight left. It would be highly beneficial if, as far as possible, we could adjust our activities to accommodate the natural cosmic rhythm, i.e. children work in the mornings whilst the yellow of mental activity is active. They are more likely to retain all the information that is given during the yellow time. After lunch, time is often spent in doing creative orange-time activities and pursuits such as dance, exercise, music and outdoor activities.

COLOUR/ ATTRIBUTE	TIME OF DAY	ACTIVITY
Yellow *Higher mentality*	Morning (sun up)	Getting up, all systems go. Alert. Mental activity. Business activity. Education.
Orange *Creativity*	Early afternoon	Time for movement, activity, play to express ourselves creatively.
Red *Energy, love, will*	Sunset	New bursts of energy, human love, procreation. The red ray. Feeds and energises Mother Earth for another day.
Violet *Purifier*	Velvet night	Time to calm down, wind down on the physical. A purging, purifying time preparing us for sleep and our night travels.
Indigo *Higher mind*	Midnight	A marvellous time for inspirational work. Under the indigo ray we receive higher knowledge and wisdom. We feel at one and in tune with the cosmos at this time.

Sky blue *Peace*	Pre-dawn	We are resting in the blue of the healing ray, our gateway to heaven colour. The colour of the sky where our spirit soars in mediation and dreams.
Green *Harmony*	Very early morning before sunrise	The green ray is seen before the sun rises, preparing and harmonising the energies for the day ahead. Silence and harmony reign and the earth relaxes. Mother Nature rests.

Balancing ourselves with colour

The chakras work together in harmony to keep us finely tuned. The crown chakra extends upwards from the top of the head and the base chakra downwards from the base of the spine. The other five main chakras open out from the front and the back of the body. Each one has a part to play in our wholeness and wellbeing and feeds different parts of the body. Our chakras can be likened to coloured batteries. When our batteries are charged we feel good and are operating on top form. When they are low, we operate sluggishly – hence we are 'off colour'. If we allow this state to continue and don't hear our body's cry, we will become unwell. If we choose to ignore the warning signals they will become louder until we can't possibly ignore them any longer and we get taken off our feet. You can help yourself by recognising the importance of your colour choice and response when you are feeling off colour. Colour preference is a need to rebalance your energy. You can work with that colour by using one of the exercises in this book. The rainbow breath (see page 29) or one of the other colour exercises will help to rebalance your chakras and give your flat battery a charge.

The chakras link with the endocrine system. This is the one system we know least about and yet it is understood to be one of the most important systems in the body. The endocrine is a glandular system that creates hormones from specific areas of the body. The table below shows which part of this system relates to each chakra and colour.

COLOUR	CHAKRA	GLANDULAR SYSTEM
Red	Base	Adrenal
Orange	Sacral	Reproductive Organs
Yellow	Solar Plexus	Pancreas
Green	Heart	Heart Thymus
Sky Blue	Throat	Throat Thyroid
Indigo	Brow	Pituitary
Violet	Crown	Pineal

Colour therapists use the medium of colour, in its many facets, to balance the whole being – body, mind and spirit. They also work towards re-empowering others to become aware of their own inner knowledge, their intuition and their ability to help themselves with the power of colour. So many people fail to recognise their own expertise in colour. They doubt their own intuitive response, not trusting themselves to know what they need. Doubt in one's self can make you question your own colour response and contradict your own feeling because of something you've read or heard. We are all as unique as snowflakes and our response to colour will differ in relation to our needs as individuals. As you progress on your path of understanding, your colour choices will continue to ebb and flow. With these changes, colour will bring you a whole new dimension of understanding.

So how do you know which colours you need? As you go through the book, there are exercises that will help you tune into and expand your intuition and awareness and discover which colours you need to cleanse, protect and fine-tune your energies. These exercises will enable you to release emotional and mental blockages that are holding you back in your life and help you discover greater joy. Do not limit yourself to these exercises or experience colour only when you're reading about it – include it in your whole life. Colour surrounds us all day; in the home, workplace, nursery, florist's, park, supermarket, college, car and shops. There are some colours, however, that stand out from the rest. Instantly and instinctively we breathe in as they strike us with that 'must have' feeling, indicating that our bodies need to absorb that colour. It may be an object in a shop window or the colour of a friend's living room. Appreciation of a particular colour is a signal that colour is calling to you. Are you receptive to the colourful messages that are open to us all? If you see a colour that you like, if

it catches your attention and makes you stop and look twice, don't hesitate to work with that colour with the exercises provided, or purchase an item in that colour to use or wear. A *Colours of the Soul®* card, a piece of coloured paper, a silk scarf or even a flower in the colour will provide you with the necessary stimulus.

Infusing yourself with colour

Place your chosen item where you can see it throughout the day and, as you look at it, take a few moments to experience how that colour makes you feel. Then close your eyes and imagine you are inhaling that colour in, breathing it into your body, filling it up, from the tips of your toes to the tips of your fingers. Imagine every part of your body is being infused with the colour. Relax and breathe evenly and rhythmically. Be aware of the way that you feel when you inhale and exhale the colour. Do you feel calm, relaxed and at peace? Are you experiencing any physical discomfort? What emotions are coming up for you? As you exhale, have a sense of your whole being releasing and letting go of any stress, tension and uncomfortable feelings that may surface. We put so little time aside for true relaxation and we all hold unnecessary tension in different parts of our bodies.

By listening to your own body's response to a colour that you love, and working with it in the way described above, you feed yourself with colour nourishment and fill your chakras with the colour energy you need before becoming depleted or overloaded. (Your body being 'off colour' manifests in dis-ease.) It also activates awareness of and your reaction to colour. If there is a colour that you turn away from, find out its complementary colour (see pages 41–42) and use the breathing exercises in this chapter to breathe the complementary colour into your system. When you see a colour that you dislike, you experience the opposite reaction to something you love. It doesn't sing to you or make you sigh with satisfaction and contentment. It turns your stomach and you instantly want to look away from it. If you see a colour that you don't like, it indicates an overload of that particular colour in your energy field. Our bodies are the most wonderful sensors and will always let us know what is beneficial or not needed at any given moment. All we need to do is pay attention and listen.

4

Magnetic, Electrical and Complementary Colours

Magnetic and electrical colours

When you think of or visualise red, orange or yellow, how do you feel? Warm, energised, alert and full of energy? Now bring the colours sky blue, indigo and violet into your awareness. Imagine yourself sitting in an all-blue room – still feeling so energised?

Red, orange and yellow are called the magnetic colours in colour therapy because they are warming, stimulating, energising and activating. These colours are grounding, acting like roots that connect us with the earth's energies and physical creation. Sky blue, indigo and violet are called the electrical colours. They cool, calm and sedate us, releasing tension and giving rise to creative thoughts and inspiration. These colours are connected to spirit and high ideals.

Green is the colour that sits between the two extremes, as it is neither warm nor cool. It brings balance and harmony and is the bridge between

the two worlds – heaven and earth (magnetic connects to the earth energies and electric relates to the heavenly energies). To function at our optimum and to experience wellbeing through colour energy balance, we need to use colours from both the magnetic and electrical colours.

Red, orange and yellow are connected to the awareness of the self, physical existence, survival instincts, self-expression, creativity, the ego and the workings of the mind. Green is the harmoniser, regulator and balancer that links to the heart, and is the key to opening the higher energies of unconditional love. This inspires and propels us to connect with our higher spiritual aspirations, urging us onwards and upwards. Sky blue is the gateway to heaven and these higher energies. Sky blue, indigo and violet connect us to the spiritual self and truths, the expression of unconditional love, intuition, cleansing, spiritual knowledge and understanding, and heaven on earth. Green keeps the fine balance between the two.

Experience is our best teacher and you may find the following exercise helpful in gaining a deeper understanding of the difference between the warm magnetic colours and the cool electrical ones.

Exploring warm and cool colours
• • • • • • • • • • • • • • • • • • • •

Find a piece of red fabric and sky-blue fabric, preferably silk or cotton. You may close your eyes if you wish. First pick up the red cloth, taking a few moments to sensitise yourself to the colour. Then note how you feel and what sensations you experience. Lay down the red cloth and shake your hands slightly to disconnect from the first colour and then pick up the sky-blue fabric. Take a few moments to readjust and begin to notice how this colour feels, noting the sensation and how they differ.

The blind children I work with love colour and its sensations. They are wonderful, clear souls who verify the existence of the unseen. Uninfluenced by sight, their senses are more alert and they describe the feelings of different colours easily. Some even tell me that each colour has its own smell! When the coloured silk scarves are laid out in front of them – even if in random order – they can tell the difference between the warm magnetic colours and the cool electrical ones. They actually feel the electrical colours as being cool to the touch and tingly whereas the magnetic colours feel warm and comforting.

MAGNETIC COLOURS
Red, orange and yellow Red is the hottest of the colours followed by warm orange and then yellow. We need these colours to ground, earth and anchor us. They also activate, energise and arouse, getting us moving and propelling us into action.
GREEN
The balancer, harmoniser and regulator, green sits between the magnetic and electrical colours and is neutral. It is neither warm nor cool.
ELECTRICAL COLOURS
Sky blue, indigo and violet These three colours represent the cool end of the spectrum with violet being the coolest of the three. They are calming, sedating, purifying, clearing and releasing.

Complementary colours

Complementary colours are those opposite each other on the colour wheel. They oppose yet balance each other, providing what the other does not have. We only have to look at the Chinese symbol of yin and yang, warm and cool, male and female, and black and white, to see how the polarities balance each other. As balance is re-established and you walk the middle ground, all things become clear.

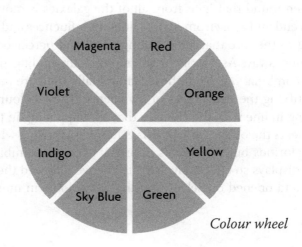

Colour wheel

If you place a silk scarf in one of the rainbow colours over a white background and focus your attention on the silk for approximately three minutes, when you remove the silk scarf, you will see the complementary colour as a haze. This is in fact the after-image of the scarf's complementary colour seen on the white background.

COLOUR	COMPLEMENTARY COLOUR
Red	Sky blue
Orange	Indigo
Yellow	Violet
Green	Pink or magenta
Sky blue	Red
Indigo	Orange
Violet	Yellow
Magenta	Green or pink

Traditional colour therapy uses these complementary colours, with the colour choice of the client, for the purpose of healing. These treatments aim to create balance in the body. For example, if red is chosen, sky blue is used as its complementary balancing colour. We need a balance between the magnetic and electrical colours to maintain our balance and function with wellbeing. However, with the energy changes of the Aquarian Age, nothing is quite what it seems. Colour and light are changing as both our consciousness and the universe are changing and expanding. The astronomer Hubble discovered in 1927 that the universe is expanding and galaxies are moving apart. It has also been found that light from all of the galaxies is moving towards the red end and away from earth. Different influences and energies are coming to the fore that are affecting us all and perceived limitations are falling away. As I work with colour, I am finding that different colour combinations from those traditionally used are more effective for rectifying the imbalances of my clients. These colour choices are changing in line with the changes that are happening in the universe. One affects the other. Perhaps this is hardly surprising when we think of the glorious but sometimes improbable colour combinations that nature displays so effectively. Isn't it time we followed the example of nature and opened ourselves to using our colours in more expansive ways?

5

Colour for Health

Colour is a therapy that can be used in conjunction with every allopathic and complementary treatment to aid and assist healing. It is safe, cost efficient, user friendly, unpolluted, aesthetically pleasing and everywhere. What more could we ask for? There are many different ways of consciously absorbing colour for your health and wellbeing. As well as those already outlined such as breathing exercises, you can choose from mediation, visualisation, *Colours of the Soul* cards, the colours you wear, the food you eat, using colour within the home and working environment, drinking coloured energised water, reflexology, art therapy, hands-on healing and many, many others.

Coloured silk scarves are a very effective and gentle way of working with colour – especially for children, babies and highly sensitive people (for more information see pages 48–57). The most powerful method is the projection of coloured light. This can only be used by a qualified colour therapist who has completed in-depth training and has practical experience. The most natural way of absorbing coloured rays is undoubtedly getting outdoors into nature and being bathed in natural light. During the darker days of winter when light is limited, it is even more important to get outside and recharge our batteries.

Because most of us live an indoor life during the winter, we often deprive ourselves of the most necessary colour rays from natural light and then wonder why we end up with the winter blues! Even if it's only for an hour a day, it's most important to wrap up and venture outside – whatever the weather conditions. Whether you walk or sit is immaterial, the important point is to be outside for a period of time, all year round and on a regular basis. We even benefit when it's a cloudy overcast day.

Whilst indoors, sit by a window or near a window if you have a choice. Remember that our skin is light sensitive and we are absorbing the coloured rays even if the sun isn't shining. In some office blocks, architects have recommended the use of coloured glass or dark glass in the windows to reflect the sunlight. It would be beneficial for colour therapists to work with architects and builders to advise on the correct use of lighting and colour schemes in these buildings to compensate for the coloured glass and to help rebalance the working environment.

The list of where colour can be used to our benefit is endless. When my own twin daughters were born twenty or so years ago, one of the girls was jaundiced. The hospital staff placed her tiny naked body under a blue lamp in an incubator for 48 hours, with a little mask covering her eyes. Interestingly, blue has always been her favourite colour.

Colour has been used far longer and more extensively than we realise. Colour combinations on packaging are carefully researched, as this is what attracts the consumer to buy – even if the competition around the product is virtually identical and on special offer! These powerful subliminal messages are widely used as many companies realise the powerful effect that colour can have on our choices. They're even aware of how colour can decrease absenteeism and increase productivity, and therefore profits and customer satisfaction.

Finding your unique colour path

As you experiment with the different methods outlined in this book, you will find your own personalised way of working with colour. Colour therapy is so expansive and diverse that it can be studied for a lifetime without ever coming to a standstill. As your awareness

and experience of the colours expands, the colours will hold greater meaning and depth for you. It may even whet your appetite to consider taking a course in colour therapy. There are many excellent accredited schools, but I would recommend that you attend a course rather than do one by correspondence. I don't believe that the learning of colour theory through correspondence is enough to enable one to become an effective colour therapist. The practical exercises that form a major part of a course are designed to develop awareness and sensitivity, and interaction with like-minded students is very important for the deeper understanding of the subject and personal growth. Not to mention the fun, play, dance and firm friendships that are made as you mutually support, network and help each other.

All the knowledge in the world cannot replace the knowledge gained from an experience.

> *The best and most beautiful things in the world cannot be seen or even touched. They must be felt with the heart.*
>
> HELEN KELLER

The benefits of colour lie in its ready availability to everyone. We can all learn to understand colour and its ability to heal and rebalance, through developing and trusting our own innate and intuitive sense of colour. My role as a therapist and colour therapy teacher is to help others develop their own insights, by empowering them to accept and acknowledge their own knowledge. In this way, they can make changes and take responsibility for themselves and their own lives.

There is no doubt that colour attracts, and whether we feel we have colour awareness or not, colour will remind us that we can recall, re-remember and rediscover a wealth of knowledge through our use of colour.

The effects spectral colours can have on our physical bodies

Here are some ways that you can help yourself and your family with colour. These examples can be used for all the colours, in the appropriate way.

Self-help with colour
• • • • • • • • • • • •

For instance, on a cold day you can wear red socks and gloves to warm your hands and feet and a red scarf or hat will ensure your head stays warm and cosy when you go outside in the cold. Think of the colours of your clothes and underwear – even your nightwear and slippers. Wearing a red half-slip, red tights or red trousers will help with muscular aches and pains in the lower body and leg. Become colour conscious. What colours surround you at home and at work? What colours do you use during the day? Think about the colour of your car, especially the interior, the colour of the paper you write on, the colour of the ink you write with, the colour of the liquids you drink, even the colour of the food you eat.

If you have chosen red as your colour choice to work with and you find it too strong for whatever reason, as a milder alternative you may choose from the orange or pink range. In the orange range of colours you may choose from the palest peach through to apricot and burnt orange. In the pink range you can choose from the deep rosy pinks to the lighter pinks. The pinks are red with added white so you will still be benefiting from the warm energy of the magnetic end of the spectrum (see page 39) but it will be gentler than the 'hot' energy of red. Should you feel uncomfortable in any way with any colour, not just red, try using it in a lighter shade or go straight to its complementary colour and use that. Remember to use the colour that you feel most attracted to. Your body knows what it needs and will call for the colour you should use. The art is listening to and then acting on the message you receive. Feel confident about your choice and trust your inner wisdom.

Be creative with your choice. You can wrap a silk scarf in your chosen colour across your shoulders as you study or tie it around your waist and you will benefit from the colour vibration as you work. Tie a coloured silk scarf in the appropriate colour around your head as a headscarf for headaches, migraine, dizziness etc. Wear your silk scarves inside your clothing to wrap yourself in colour energy whilst relaxing at home.

Bring into the home and workplace appropriate coloured flowers and plants. At work, have desktop accessories in bold blocks of your colour choice; a photo frame in a certain colour placed on your desk, for example. Crystals can be used effectively at home and at work, so seek out the crystal kingdom and choose appropriate colours. Look at the food colour chart on pages 100–101 and take foods from the red section if you want to warm

your insides and give your system a boost of energy. Use colour-energising carrier oils for massage (see pages 85–91 for further details) and use colour-breathing exercises to breathe colour into your system. Be innovative and use your imagination. There are countless ways in which you can help yourself with colour once you understand and experience how each colour is affecting you. It is important for you to work with colour in ways that feel right and appropriate for you and your loved ones. Remember that there are no good or bad colours, they all have their place. Experiment and don't get stuck on one or two colours in any area of your life, especially in your choice of colour for clothes. Everyone can wear every colour, the art is choosing the correct shade. For example, some people say they can't wear yellow because it makes them look sallow but they are surprised when they see how flattering a rich golden yellow is on them. Experience your reaction to all the colours of the spectrum and benefit from the vibration of all of them.

The joy of working with colour in the ways suggested in this book is that you cannot overdose. The colour will do its job and once the body has absorbed what it requires, the colour energy will cease to flow. There's no need to be apprehensive, all you need to do is enjoy and benefit from the experience. By allowing your mind to quieten and focus on the breath, colour will work its magic and you will just know when your body has absorbed enough of it.

Making colour-energised water

To colour energise water you can either use a pack of coloured gels or use coloured glass containers in the appropriate colour. The container must be glass, do not use any other material. Fill the container with still spring water, cover with a muslin cloth or food net and place the container on a windowsill where it catches the sunlight. In summer the sunlight is brighter, therefore you need only leave your container in the sun for two to three hours before placing it in the fridge. In winter when it is dull and overcast and the light is poorer, you can leave the container on the windowsill all day. Use this same method to colour energise oil.

Using silk

A good way to work with colour is by using silks in the colour needed for healing. Use a stand in your hall to lay the scarves on so that your family can admire or take and use them freely. Silks are used in colour treatments and these can be purchased in the exact spectrum colours. They usually come in two main sizes, the largest will cover the body and the medium size measures 36in (90cm) x 36in (90cm). A colour therapist will usually have ten silks, seven in the colours of the spectrum plus magenta, white and pink.

The silks can be used at home in numerous ways. If you have a sore throat, a blue scarf tied around the throat area will assist in rebalancing and healing. Wear your colour choice under your clothing or lie down in white underwear, a white nightdress, or even naked and cover yourself with your colour choice. If the sun is shining, lie by a window with the sun shining on to you or, if possible, lie outside in the sun. It's a good idea to time yourself when you first start using the scarves. Use the first colour choice for 20 minutes and then use its complementary colour for 20 minutes. As you begin to do this regularly, you will intuitively know when to move on to the complementary colour and when your colour treatment is complete. It may be longer than the times advised above, and at times you may feel like only using the first colour choice. Trust your inner knowledge.

Children love both the colours and the feel of the silk on their skin and need little encouragement to make their choice. After a particularly stressful day at school, they can benefit tremendously from using the coloured silks. Let them choose their colour and gently suggest that they go and lie down, maybe with a favourite book, and cover themselves with the silk. Or they could wrap it around their shoulders as they sit at their desks or watch television. Sky blue will reduce a child's fever, cooling and calming their system.

You may feel that silk is inappropriate for younger children. If you do, you can use pure cotton in the appropriate colours. Lengths of material in the spectrum colours can be used in the same way as silks. These are easier to wash and care for than silk and younger children may prefer smaller pieces of cloth to handle and hold. There are no right or wrong ways and it's simply a question of finding the right choice for you and your family. A friend of mine with a young daughter found that tying a ribbon of her colour choice around her teddy's neck was great for her. Teddy went everywhere with her daughter and when it was time for a bedtime story, she would absorb the colour of the ribbon as she lay and cuddled him.

Cleansing your scarves
● ● ● ● ● ● ● ● ● ● ● ● ●

When using the silks or any 'tool' for healing purposes, remember to cleanse them after each use. To cleanse and clear the energy from the scarves without washing them, hold each scarf in your left hand and sweep your right hand gently down and away from it, starting at the point where your left hand is holding it. As you do this, link to the light and ask that all that is negative and impure be cleared and cleansed from the scarf, all the while imagining you are infusing each scarf with light. Do this with each scarf either three or seven times.

Red

Red has the longest wavelength, the lowest frequency, and the slowest vibration. Red is the fire of the spectrum and the hottest colour. It arouses our passions, raises our body heat, stimulates the heart and increases the heart rate. It raises blood pressure and increases circulation and body temperature. It builds up blood cells in the body, strengthens stamina, stimulates appetite and has an effect on the bowels, pelvic area, legs, hips, joints and base of the spine.

Red feeds the muscular system and is the greatest energiser. Red uplifts and helps to alleviate feelings of lethargy and inertia. It can also make us feel agitated and increase feelings of anger, anxiety and frustration. Red can cause hyperactivity, making it difficult to rest and relax.

Red releases adrenalin into the bloodstream. Red can fire our enthusiasm and creativity. Red is the deep throb of the drum, of the pulse and the colour of blood – of life itself. It is the colour of birth and sometimes death, the colour of war and the sexual dance. Red can make us blink more, blush, have a hot flush, feel restless and unable to sit down for long. Red arrests attention, it is an antidote to feeling slow and dull. It has a dynamic power. Red resonates with our base needs, our survival instincts, and our sexuality.

Red makes us feel courageous and fires our strength and will.

Working with Red

● ● ● ● ● ● ● ● ● ● ●

Chilblains are helped by bathing them in red energised water. To give yourself extra get up and go when you feel sluggish in the morning, sip a glass of red energised water. This will also help a child who is off their food. Do not give this in the afternoon, however, as it is too energising and will affect his or her sleep. Red, orange and yellow energised water should be taken in the mornings. Take sky blue, indigo and violet energised water in the afternoon and evening.

If you're tired from a long day and have an event to attend straight from work, think and breathe red into your system for a few minutes to give an extra boost to flagging energy. Red energised water on a cold morning will warm you through. Use blue tack to attach the red colour card to your bedside table. As you turn off the alarm, focus on it for a few moments and you'll soon be up! To raise low blood pressure wear red, drink red energised water, and focus on the red colour card throughout the day. Low libido? Spend moments during the day imagining yourself surrounded in a deep rosy pink bubble. Once you have 'built' your bubble, imagine pulling the rosy pink into your pelvic area with every in-breath you take. Massage rose essential oil mixed into a light carrier oil on to your pelvic area and lower back. Place three drops of rose oil into 15ml of carrier oil. (Rose oil is the finest pure oil with the least contra-indications – it takes thousands of petals to produce just 1ml of oil, therefore it is expensive.) Programme a rose quartz crystal to energise this part of you and place the crystal on to your pelvic area as you relax in the evening (see page 95 for information on how to programme crystals).

Wear a red T-shirt or top when you go out on your next run and time yourself. Are you faster? Gardeners, try watering your apple tree with red energised water two weeks before picking the apples – note the beautiful red apples.

Claire boosts circulation – with Red

Claire suffered from poor circulation and always felt cold, so each morning she would sip a tumbler of red energised water, taken from the jug she left permanently on the kitchen windowsill. The jug was made of deep red glass and she refilled it each day with fresh still water. As her kitchen was south facing, the sunlight poured through the window

catching the red jug of water and infusing it with red energy. Her daily routine of 'red' water each morning made a difference by warming her body and activating her circulation.

Sam gets off to a better start – with Red

Sam couldn't get out of bed in the morning. He had got into the habit of turning the alarm off and turning over. When he did surface, he was late. He then spent a frenzied 15 minutes washing and dressing before flying out of the door only to arrive at work stressed, exhausted and late. Fed up with this routine, he began using the red Colours of the Soul card.

Sam placed the card beside his alarm clock. When the alarm went off he simply focused on the red card for four minutes. This gave him the get up and go to start the day in a much more efficient way.

Orange

Vibrant orange energy is not as 'hot' and potent as red but more of a warming glow. It is still energising and activating, but in a gentler way than red. The lighter oranges and the peaches release youthful creativity. Orange has a direct effect on the digestive system, calming and soothing it. It has a milder effect on the sexual organs, on the circulatory and reproductive systems (relationship problems may manifest as sexual or reproduction problems), pancreas, spleen, kidneys and bladder. It gives relief to asthma sufferers, and holds the balance of fluid and liquids in the body. Wonderful for menstrual problems and for relieving painful periods, it also influences production of testosterone and oestrogen, frees phlegm and wet coughs. There is a wholesomeness to orange, it gives us relief from the uncomfortable symptoms of cramps and spasms. The joyfulness of orange is an antidote for depression and loneliness. Orange helps us to release emotions. It liberates us and helps to disperse fears, increases tolerance levels, and can help with tiredness.

Working with Orange
● ● ● ● ● ● ● ● ● ● ●
If you want to feel liberated, wear orange clothes or a silk scarf and breathe

orange in when you need a lift. For the relief of painful periods, rub warm, orange energised massage oil on to the stomach and lower back. For muscle cramps, breathe orange into the area as well as rubbing in orange energised oil. Soak your feet in orange energised water to relieve swollen ankles. Wear an orange scarf inside your clothes or tied around your waist to give relief from any discomfort in the lower trunk area. If you're feeling low, use some orange breathing exercises, and write on orange paper. Place the orange colour card within your vision so that you can see and absorb the energy as you work. Wrap yourself in orange energy by wearing a scarf around your shoulders or an orange top. Drink fresh orange juice, eat peaches, papaya and apricots. Place a picture of yourself or a loved one in an orange picture frame and leave a programmed orange crystal (see page 95) beside it for healing. Stick the orange colour card to your bedside table by the alarm; when it goes of, focus on the centre of the orange card and feel the happiness of orange swell within you. The colour orange is the grin of the Cheshire cat, the colour of happiness, laughter and play.

Feeling blue? Orange and indigo together are a striking combination. Take these two colour cards and first focus your attention into the centre of the indigo card for three minutes then repeat the process for three minutes on the orange card, now close your eyes and relax.

Yellow

Yellow feeds the nervous system and helps to clear it by releasing blocks in the solar plexus – the brain of the nervous system. Yellow stimulates the mind; it is the colour of the intellect, giving clarity and clear, focused thinking and reasoning. It is good for studying. Yellow will bring relief to arthritis, aid exhaustion; act as a laxative and weight corrective, it is a stimulant, and cleanses and flushes out the body. Yellow can be used for constipation, to pass more urine, for water retention, and helps to flush calcium deposits from the body. Yellow is the colour of self-assertion and the realisation of the ego. Yellow can give us confidence and will lessen feelings of inadequacy. It can help us to feel empowered.

Working with Yellow
• • • • • • • • • • • •

When studying, wear a yellow scarf around your shoulders, use a yellow bulb in your desk lamp, write on yellow paper. Use yellow while revising and on the day of your exam, focusing on your yellow colour card when you feel you are flagging or going 'blank'. For nervous tummy, breathe yellow in for a few moments.

Drink yellow energised water to cleanse and clear your system, as a skin tonic for greasy skin and to cleanse skin after removing make-up. Drink fresh lemon in hot water every morning to freshen and cleanse internally. Use the juice of one fresh lemon in a pint of warm water as a final rinse to lighten blonde hair naturally. Yellow is an excellent aid for dieting and will help you to cut down your food intake. Stick the yellow colour card on to the fridge door or food cupboard and before you reach for food focus on the card for a few moments. Keep a yellow jug of water on the windowsill, drink a tumblerful of yellow energised water half an hour before meal times to satisfy your hunger. This will help you stick to your diet. Drink yellow energised water freely during the day to give relief from feeling bloated, water retention, and urine infections. Yellow is also helpful for giving up smoking and for the after-effects as toxins clear out of your system.

Having yellow flowers in the home will bring the sunshine indoors and cheer you up. Focus on the yellow colour card for a few minutes to encourage feelings of cheerfulness, alertness and to boost your confidence.

Green

Green regulates and harmonises blood pressure, the nervous system, soothes the heart centre, relaxes the heart and is calming to the whole system. It's good for neuralgia and relieves tension and stress. It gives us the resolve to earth ourselves and bring our ideas into reality. Green is a neutralising colour; it creates balance, soothes our beings and promotes feelings of self-love. When you feel the need for calm, use green. It is the colour of good health, peace, space and harmony.

Working with Green
• • • • • • • • • • •

Eat as many greens as possible. Focus on the green colour card and

breathe it into your system. Drink green energised water to ease stress and to strengthen the system. Wear a green hat or scarf to quieten the mind. Putting a green coat on a nervous animal or putting a green cloth in their bedding will calm them. Giving them green energised water as drinking water will have the same effect. Wrap yourself in a green silk scarf immediately after shock and drink green energised water with Bach Rescue Remedy added. Wear fern green to stabilise and strengthen inner resolve. Fresh lime and vibrant apple green will stimulate you into earthing your ideas and creating new beginnings in your life. Breathe green into your system to relax and to lower blood pressure. Walks in the green of nature give us the space and peace we crave, but too much green and we stop doing and lose track of time.

Sky blue

Sky blue is anti-inflammatory, antiseptic and good for teething problems (children are naturally drawn to sky blue and apple green). Sky blue is restful and can give us feelings of peace and serenity. It will take the heat out of inflamed areas, the sharpness out of stings, and will alleviate itches and rashes. It calms and cools the system, helping to reduce fevers. It feeds the respiratory system and has a direct link to the thyroid. Thyroid imbalances can be helped with sky blue or indigo. Use for insomnia and high blood pressure. Sky blue can help with eating disorders. Sky blue calms the nerves and the emotions, relieves anxiety and soothes the whole system. It gives us hope and trust as well as calming the mind.

Working with Sky blue

For sore throats and mouth ulcers gargle with sky-blue energised water and wear a sky-blue scarf around the throat. Bathe burns in sky-blue energised water. Use energised sky-blue water for ruddy complexions to decrease redness. Soak a cotton ball in the energised water and wipe your face, leaving it to dry naturally. Use sky-blue energised carrier oil for restless, hyperactive children. Massage warm oil into the feet, back, neck, tummy, shoulders and arms. If distraught, use sky blue to calm and then orange to clear and uplift. Use the sky-blue colour card when you need deep

relaxation and inner peace. For a fretful child, use the colours sky blue and pink when colouring in or cutting out coloured paper. To elevate your thoughts, wear a sky-blue hat or scarf. Wear sky blue and yellow to give you confidence if you're speaking in public.

Jake is soothed – with Sky blue and Pink

Jake was soon settled when Mary sat and coloured with him using sky blue and pink crayons. First she drew and coloured in two circles, one in sky blue and one in pink, in the middle of two blank pages of paper. She then asked Jake to colour around them in the two colours. While he was 'playing' and in the comfort of his mother's presence, his gaze was constantly drawn to the sky blue and pink circles. The colour energy quickly settled and calmed Jake.

Indigo

Indigo cools and is a system purifier. Used with orange it is useful for chest and lung problems. It is also good for boils, ulcers, varicose veins and shingles. Indigo cools heat rashes and helps with insomnia. Indigo will lower body temperature, is cooling and calming, and can relieve pain. It will soothe and cool a child suffering with measles or chicken pox. Indigo also helps with rheumatism, arthritis, eczema and bruising. It aids in decreasing the size of fibroids and helps stem the flow of heavy bleeding. Indigo can bring out and release fears, will calm the mind and can help with mental complaints. Indigo or sky blue can be used for burns, stings, itches and rashes. It protects and nurtures and skeletal system, promotes the healing of wounds, protects the aura and stimulates the parathyroid gland.

Working with Indigo

Indigo energised oil can be used for massaging restless and highly-strung adults. For hip and joint problems, wrap the lower body in an indigo silk scarf, wear indigo-coloured trousers and massage the energised oil on to the lower trunk area. Sip indigo energised water before sleeping for relief from night sweats and hot flushes or use indigo-coloured pillowslips to aid

sleeplessness and sweats. Wear an indigo hat or scarf to help calm irrational fears. Boils, ulcers, varicose veins and shingles can be eased by drinking indigo energised water and applying indigo energised oil to the affected area.

Use the indigo colour card just before meditating. Focus into the centre to absorb the qualities of the indigo ray which links us to the heavenly worlds.

Stressful day? Use the indigo colour card for four minutes. As you look into the centre of the card, breathe the colour in. You will experience a deep sense of relaxation.

Lucy helps her varicose veins – with Indigo

Lucy suffered from aching legs caused by varicose veins. She wore dark blue tights during the day and each evening she soaked her feet in indigo energised water. She massaged her legs nightly with indigo energised oil and gained tremendous relief. Her legs no longer ache and her veins have not been inflamed since.

Violet

Violet has the shortest wavelength and therefore the highest frequency and fastest vibration. Violet purifies the blood and restores calm to the body and mind. Use for nervous headaches, eye and ear problems such as tinnitus, discharge, liquid ear etc. It rebalances the inner ear, clears chronic sinusitis and can help in alleviating snoring. In some cases it can assist in lower back problems, fertility problems and is good for skin conditions such as acne. It can also help with scalp problems.

Working with Violet

For scalp problems, i.e. psoriasis, rinse your hair with violet energised water after washing. Alternatively, energise a pure, light carrier oil with violet and massage into your scalp. Wrap your hair in a hot towel and leave for ten minutes before rinsing out.

To suppress hunger and as an aid to dieting, sip half a wineglass of yellow

energised water 30 minutes before you eat and half a wineglass of violet energised water 30 minutes after you've eaten. Wear a violet scarf or hat to ease headaches and migraines. Wear a violet scarf around your shoulders for exam nerves. Warm and energise violet oil and massage into and around the nose, cheeks and the front and back of the neck to ease sinusitis and snoring. Begin by bringing violet into your awareness. Gently place your index finger over your right nostril to close it. Imagine breathing violet in through your left nostril to the count of nine. Exhale through the same nostril at a normal rate. Repeat with the same nostril five times. Then repeat with the right nostril. This will clear the nasal passages and help prevent snoring.

A foggy head can be cleared using violet with the breath. Writers' block, artists needing inspiration and any creative block can be released by working with pale violet with the breath for 30 minutes. Violet urges us to give of our very best and aspire to higher ideals.

Violet will help soften and improve skin tone. Massage your hands and body with violet energised oil. Scar tissue, skin blemishes and even eczema will find relief with violet. Gargle with energised water for sore gums and sip energised water to aid in detoxifying the body. Soothe earache by using warmed violet oil, massaged around the ear and neck.

Place violets, irises or Sweet Williams on your desk or table so that your gaze can rest on the violet colour regularly throughout the day.

Work with the violet colour card before sleep. Just three minutes is enough as violet acts quickly. This will also help snoring and will ease you gently into the land of nod.

6

Easing Stress with Colour

Colour therapy can help us enormously with a very modern problem – stress. In this day and age we all seem to be on a massive burnout and overload. So much more is expected of us and stress has become responsible for many of our problems. It is how we deal with day-to-day stress that is important for our overall wellbeing. Technology is flying ahead of us, and even faster and more sophisticated microchips are only moments away as we increase our ability to transfer and communicate information via terminals etc. With stress, we produce more adrenalin, too much of which creates an imbalance in the body, often leading to symptoms of depression. Tension, restlessness, anxiety, insomnia and hyperactivity can cause outbursts of fear and panic, irrational feelings, inability to concentrate and even personality changes. We are so busy racing around, achieving, completing our long list of tasks for the day that we can often feel as if we're not achieving anything and begin to feel helpless and unable to cope. A cycle of tense anxiety and lethargy often ensues. Our tiredness is the result of our chattering minds that become so busy and overloaded with what needs to be done or can't be done. In the end, our physical bodies become exhausted. Add to this the guilt of what we feel we

should be doing but are too tired to, and we have created a recipe for disaster. We feel as if we're stuck on a roller coaster with no way of getting off.

Each day seems to melt into another week and it seems that no sooner have we planned and celebrated Christmas, that it's time for that man in the red suit to arrive again! It's important that we all become more discerning with our time and not take on more than we can cope with. There are so many things that we want to do and new things that we want to learn. It seems that the more we learn and experience, the more we realise how little we know. Each new road opens the way for many new turnings, even cul-de-sacs. To be open to new experiences and be able to take full advantage of them, we need to be realistic with ourselves and ensure that we are balancing our time. In that way, we can enjoy each experience and every moment and not need to be rushing to the next for fear of missing anything. This is applicable to all life experiences.

When we are happy, we feel on top of any situation and when we feel sad, the reverse is true. Our emotional and mental wellbeing, as well as our physical health, will suffer when we are not happy and positive. Our feelings as well as our bodies give us subtle messages that are important guides through the maze of life. We can all strive to ensure that we go up the ladders and not down the snakes. If a person or situation makes our bodies creak in any way, and causes us to feel uncomfortable or even pain, then we must listen and act accordingly. When we are anxious, our bodies react with tension, headaches, nausea, fatigue, digestive upsets, palpitations and even high blood pressure. If we refuse to listen to these early signs, the symptoms will increase until we are forced to identify and look at the cause.

We can work towards upliftment by changing our outlook; with laughter, smiles and a positive outlook to life. When we learn to flow with changes and events in our lives, our bodies feel good and happy hormones kick in to aid and assist us. Allowing worries and stress to literally eat away at us results in ulcers and digestive problems. We can even create a urine infection when we are literally 'pissed off'. Our skins itch and blemish when we allow someone or something to get under our skin, and our bowels creak and strain with constipation when we hold on to old stuff. A busy person who never even feels that they have time to go to the toilet in peace might develop piles.

Regularly using the phrase 'pain in the butt' will create pain in your rear end. The examples to illustrate the mind/body connection are endless. Our physical bodies respond to messages from the mind. Are you an optimist or a pessimist? A jug can be half full or half empty. It has been proven that optimistic people are more productive, healthier, happier and will live longer. Think cheerful! Listen to yourself – what regular statements are you giving to your body? We can impress upon ourselves positive or negative programming. If you go around saying that you always feel tired, you will continue to feel that way. Let go of negative statements and thoughts and replace them with positive input. To help yourself, flood your system with colour, colour affirmations (see pages 68–70) and positive statements.

Putting a smile on our faces is so easy to do and truly makes a difference to how we feel. With a smile you send positive messages to your body and mind. Sit for a moment with a glum turned-down mouth and then replace it with a smile. Have a sense of your whole being feeling uplifted, lighter and brighter. Practise smiling more. Give your system a good workout by laughing – it relaxes the muscles throughout your body, releases tension and helps you to see the sunnier side of life. When you next go shopping, treat yourself to a special present and ask for it to be gift-wrapped. Make this a regular event. When we work with colour and breath we are well on the road to being healthier and happier.

Every day in my own practice, clients from all walks of life share their concerns about how very little quality time they have for themselves and their families. Many feel tired, even exhausted, and fear losing their jobs, or having to increase their workload, or not being able to cope with technology changes. They feel that they're on a racing track with no finishing line, and they wish that they could take time out to enjoy the simple joys of life.

Practical ways to alleviate stress
• •
Stress will escalate unless we take active steps to quiet the mind, body and spirit. Walks in the green of nature will help to bring us back to earth and ground us, calming and easing tension and lowering blood pressure – often a physical symptom of stress. As we walk in the green we can clear our mind of endless chatter by experiencing the moment, breathing deeply and evenly

and focusing our full attention on the natural surroundings. Rather than staying indoors at lunchtime, spend time in open green spaces. Set the alarm clock half an hour earlier and spend the extra time walking in the park. Green is the most favoured colour of nature and is the colour of harmony and balance. We all feel so much better when we take a trip to the country. Even if you can't get there as often as you would like, you can feed yourself with green every day.

If the weather is good, take off your shoes and socks and walk barefoot on the grass and make a real connection with the earth. Do you remember the feelings of freedom you experienced as a child? Children naturally want to go barefoot and instinctively know how to play. Look in awe at the natural beauty, clearing your mind of all thoughts and allow yourself the luxury of fully experiencing the moment. Cast your eyes around and look at the profusion of fabulous colours in nature. Focus on the colour that seems to stand out from the rest and imagine you are breathing it into your being. Smell the air and breathe it deeply into your lungs.

In our busy lives we walk on concrete paths or take some form of transport to our workplace, and that is where we usually stay until it's time to go home. Our indoor lives are contributing to our lethargic, stressful states. Whenever you get the opportunity, feel the grass under your feet. When you're on holiday, enjoy making a connection to the earth's energy by walking on the sand, in the sea and barefoot on the earth. You'll feel more alive, happier and well. Don't wait for your annual holidays to make that connection to the earth's energy and the elements.

Observing the natural world

Here's one of the practical exercises I use in my courses. You can try it for yourself. Students often make comments such as 'I'd forgotten how nice this is', or 'I'm usually far too busy to make the time for this at home.'

After lunch, when everyone is full and contented and the body is winding down, I ask the students to find a comfortable spot on the floor, to lie on their side and look out of the window. My courses are held in a beautiful natural spot in magnificent grounds, and the view from the windows is superb. If you're doing this at home, make sure that you take the phone off the hook and that you won't be distracted. Find a spot where you will be warm and comfortable and can look into nature either lying or sitting

down. Simply observe everything that is within your range of vision; watch the colours that predominate as the light changes and moves on the trees or grass and as the clouds move across the sky. Observe the animals, the birds, the insects, dew drops glistening on a spider's web, the falling leaves, and notice your own body and your reaction to being still and silent. It may take you a while to relax – you may be fidgety and your mind may even tell you that you are wasting time and that there are far better things to do. Stay with it and resist the urge to get up and do something. It is interesting for me to observe the students during this process. For the first few minutes they fidget and tussle with being asked to do nothing but lie in silence and observe the beauty of nature. How uncomfortable this 'doing nothing' is for the doers, and how sad that something so natural and beneficial should feel so alien. How easily we forget what surrounds us, and the importance of taking time out to experience and benefit from it.

Another exercise is to lie on your back on the grass and look up into the sky. You can lie under the shade of a tree or, if you prefer, out in the open. Do you remember when you lay on the grass and made shapes from the clouds?

Carving arrows
● ● ● ● ● ● ● ● ●

The carving and decorating of arrows is another exercise I use and it's one that is sure to bring up issues. A bonfire is built and the students are asked to go out into the grounds to search for two sticks, one straight and one crooked. On their return, they proceed to carve and shape their sticks into arrows and to decorate them with flowers, leaves, feathers, anything they have brought with them or found in the grounds. For some this is a thoroughly enjoyable exercise that causes happy memories of childhood to come flooding back and, with that, new ideas and inspiration that can be used in the here and now. The students keep the straight decorated arrow as a reminder and a symbol of all that is new and bountiful that they wish to bring into their lives.

We all go outside to light the bonfire and, during the bonfire ceremony, they burn the crooked arrow and anything else they may have brought along with them for this purpose, as a symbol of all that they want to clear and let go of in their lives.

Identifying and releasing fears

To identify and release your fears, light a white candle and place a plate next to it. Write whatever is causing you the greatest anxiety at this moment on a clean piece of white paper and fold it in half three times. Hold it in your hands between your palms for a short while, and then light it from the candle. Place it on to the plate and then affirm quietly to yourself, 'I will not be held in fear and I ask for this problem to be resolved on the highest level, in the light, at the right time and for my highest good.' It's important to ensure that all the paper is burnt.

Take the ashes and put them outside in the garden and cover them with a handful of soil. If you don't have a garden, you can put them in a window box or a potted plant that you keep outside. As you do this, mentally let go of the problem and know that it is being resolved on the highest level.

Scanning your body for stress

When we are stressed our minds seem to detach from our bodies, our thoughts run amok and we become unaware of how we are holding ourselves. You may find it helpful to carry out a body scan during the course of the day. Stop at different times during the day, sit quietly and mentally turn your attention inwards, moving through your body and noticing the areas that are tense and holding discomfort. How is your posture? How are you holding your shoulders? How tight is your jaw? Are you grinding your teeth? Be aware of any feelings or images that come up and then relax and breathe into your body, allowing the tension to dissolve on each out-breath. Trust what you see and experience when doing this exercise. You impulses and feelings are correct. As adults we often depend upon our minds and reason, often to the exclusion of our intuition. We so often rely on other people's thoughts and opinions to guide and support us and verify our actions and experiences – but what about relying on our own feelings and impulses?

Our minds are so busy going over and over events that we become overloaded and unable to cope, forgetting what is beneficial for us. When we are relaxed, our minds are clear and we feel energised. As our thought energies flow positively, we feel refreshed and are able to prioritise and cope with life.

There are many high-priced stress gadgets available, and many are nothing more than glorified thermometers. Anyone can be a stress manager and enter the world of stress management. Most tackle symptoms and not causes, and charge corporate clients as much as £1000 per day for their services. The problems may be temporarily dealt with, but not permanently resolved.

Exercise is recognised stress buster. It releases endorphins: hormones created by the body that are connected to the pleasure centres in the brain and have pain-relieving qualities. This release of endorphins produces the feel-good factor experienced after exercising. Many companies are investing in gyms for their workforce, to encourage corporate fitness. But this is just one area where we can benefit. How much more powerful would exercise be if we used our colour exercises and knowledge of colour to exercise in the right coloured surroundings? I hope more companies will look at their colour schemes, not only in the gym area, but throughout the building. The effect of lighting on staff who spend eight hours or more a day in their work environment is also an important consideration. Unfortunately this awareness is not as widespread in the UK as it is in others, but more and more people are recognising the positive effect of lighting and colour on the workforce. The effects of colour therapy cannot be underestimated and enough research now exists for companies to take it seriously. If you combine colour therapy with natural lighting, you will have a productive and healthy workforce. And that means less absence through illness and greater productivity.

Tom gets through a stressful time

Tom arrived looking downhearted and bedraggled. His body language spoke volumes – dropped shoulders, a bent back, a taut, ashen face and hands and feet that didn't know quite where to put themselves. In his quiet, unassuming manner Tom began to tell me his story. His wife of 30 years had just been diagnosed with cancer. Tom was due to retire in six months' time, and they had been planning for his retirement for ages. They had bought a motor home and excitedly made travel plans. They had saved and planned for this time with excited anticipation, and now this bombshell had been dropped. Iris, his wife, had a progressive cancer and had been given only a short time to live.

The shock, pain and disbelief were etched on to Tom's face; his world was shattering in front of his eyes. Colour therapy helped him to regain his inner strength and composure and come to terms with the shock, so that he could be strong and supportive for Iris in her short time left. After she had passed, Tom continued his colour treatments and worked on his exercises between appointments. What most surprised him at first, and came as a relief to his daughter, was his ability to release feelings and emotions after a lifetime of keeping a stiff upper lip. As a result, he unashamedly went through the grief process. The colour and inner work brought to the surface many other issues that Tom had tried to put out of sight and mind over the years. He was now able to recognise and deal with them.

Months after starting weekly and then fortnightly treatments, Tom looked serene and emanated peace. He held himself tall and proud and even looked younger. By going through his dark night of the soul and acknowledging and working on the issues that needed to be brought to 'light', Tom worked his way to wholeness. As a result of his treatments, Tom's eyesight improved and his optician downgraded his prescription, much to his bemusement. Numerous aches and pains also dissipate.

Tom now enjoys taking time out to experience colour and its effects on him. He stays in the moment rather than jumping ahead of himself or getting stuck in the past, and focuses his attention on the job in hand. He takes time each day to do his colour exercises and drinks plenty of water rather than endless cups of tea. He prepares himself colourful meals and sits and relaxes, enjoying every mouthful. Gone are the days of eating on the run.

Colour not only went to the source of Tom's presenting problems, but it also brought up and cleared the past dross that he was holding on to. His family is thrilled to see their dad with so much life and vigour, and his grandchildren have an active and playful grandfather. Tom was prepared to take responsibility for his own health and wellbeing and bring the joy of colour into his life. Colour is not a treatment – it is a way of life.

7

Working with the Mind and the Breath

We've already looked at some of the ways in which we can help ourselves with colour. In this chapter we'll explore in more detail how we can make our minds and our breath work with us in the healing process.

Breath, oxygen and life

Everywhere that you go on this planet, air is readily available. Governments will never be able to put a service charge on it. It is free for all of us to use and yet so many people breathe shallowly, not taking in enough oxygen. Of all the chemical elements, oxygen is the most vital to the human body. In spite of the fact that we can survive for days without water and weeks without food, we can survive only minutes without oxygen. Oxygen is life-giving and sustaining and approximately 90 per cent of our energy is created by it. Nearly all the body's actions and activities are regulated by oxygen. Every one of the

body's cells demands oxygen for correct and proper function.

Today we are experiencing a decrease in atmospheric oxygen as a result of pollution, deforestation and global warming. Shallow breathing results in fatigue and even illness so it is important for us to breathe deeply and naturally. As we breathe out, we assist the body in flushing out toxins and waste and letting go of stress and tension. Adequate oxygen allows us to strengthen our systems and has a positive effect on our immune systems. Breath work with colour helps us to stay in the here and now. It also aids us in clearing out and spring-cleaning on all levels, enabling us to travel 'light'.

Be prepared for many positive changes in your life once you begin to work daily with colour and the breath. One of the most beneficial ways to breathe in is through the nose and exhale through the mouth. We take respiration for granted and yet it controls the quality of our vitality and our life. Working with the breath and colour gradually begins to affect the cells, filling them with light, illuminating the chakras and changing and raising our consciousness.

Colour affirmations

There is no mystery about colour affirmations. They are positive statements using colour and when used regularly and repeated many times, are effective in raising our vibrations. Affirmations have the power to change our outlook and our thoughts and are an excellent healing aid. When you construct your affirmations, frame them in the present tense. They can be spoken out loud or silently to yourself. Affirmations are designed to displace negative thoughts. Make your affirmations very positive, for example: I *am* bathing in red energy, rather than, I *wish* I was bathing in red energy. This simple change allows the sentence to become an affirmation.

You can create your own appropriate affirmation to suit each situation. Use your positive statement on each in-breath to aid your focus and prevent your mind from wandering. Then sense a feeling of releasing and letting go on each out-breath. We combine colour with affirmations to bring in the effect and quality of the colour with our positive statements. If you choose red as your colour and feel in need of both a boost of energy and grounding, you could use 'I am brimming with red energy. I am connected and grounded to Mother Earth'. As well as positive statements to uplift and elevate and change your thoughts, you can use colour affirmations for any part of your

body to ease discomfort and tension. If you legs are holding tension and feel tired and aching, you could use, 'My legs feel light and relaxed and are bathed in blue.' Each time you will need to choose the appropriate colour for the body part that needs colour healing.

Repeating the affirmation many times reprogrammes your mind-computer with positive colour statements and colour energy that will feed and nourish your body. There's no limit to the wonderful affirmations you can create to suit your life and your circumstances. Whatever tension is held in the body can be eased with colour affirmations, but make sure that you keep your focus on the relevant body part as you repeat them.

A lot is written about getting in touch with our bodies, yet most people don't know how. Colour is one of the many ways that you can get in touch with your body and help yourself at the same time, by feeding yourself positive colour statements. You can also use affirmations to affirm positive experiences in your life. If you are not sure which colour to use, you can always use white, remembering that white light contains all the colours of the rainbow. You cannot overdose yourself with colour as your body will only take exactly what it needs. Here are some examples of colour affirmations you could use:

RED	With red I have the courage to move forward.
ORANGE	I am brimming with orange, full of enthusiasm for life.
PEACH	I am spontaneous and carefree in peach.
YELLOW	With yellow I am open and willing to change.
GREEN	I live and breathe in green harmony.
PALE GREEN	I welcome new beginnings into my life.
SKY BLUE	I cherish and nurture myself in blue.
INDIGO	With indigo, I have faith in my abilities.
VIOLET	In violet I am guided by the divine source.
PINK	In pink, I speak, think and act in love.
MAGENTA	Love is everything, an abundance of magenta fills my body.

WHITE	White floods my being and illuminates my mind.
GOLD	I am guided by the gold of divine wisdom in all my affairs.

When we use our minds with breath, we can change conditions within and without by using a positive affirmation and breathing it into us with colour. In the same way we can breathe out any negative emotion or feeling such as anger or frustration. The more we breathe in a positive thought, the longer it will stay with us and have a positive effect within us. The same applies to the out-breath. The longer we breathe out stress, tension and pent-up emotions, the more we relax and let go.

Working with the breath

Take yourself somewhere quiet and lie down, telling yourself to relax. Experience every part of your body from your toes to the top of your head relaxing until you sense yourself sinking deep into the surface you are lying on. Breathe in through your nose and feel your stomach rise. As you breathe out through your mouth, experience your stomach sinking down again. No movement should be felt above the waist. Keep the ribcage still and concentrate on slow, deep intakes of breath through the nose. Hold for a few seconds as you imagine this life-giving energy feeding your whole self. Then exhale and feel your stomach going flat. Place both your hands on your navel area as you carry out this exercise. Once completed, you will feel very refreshed, relaxed and at the same time energised.

Monitor your breath

A sigh is the body's way of reminding you to breathe properly. It's a wonderful mechanism geared to good health and wellness. We all need to listen more attentively to the language of our bodies. Monitor your breath throughout the day. How are you breathing? You can place your hands over your navel to remind you to carry out the breathing correctly. Wherever you are and without drawing attention to yourself, you can spend a few moments doing this. You may also find that breathing in as you count from nine to one before you exhale is beneficial. To breathe properly is as fundamental to our good health as consuming enough water daily. Many of

us drink anything and everything – tea, coffee, fizzy drinks, yoghurt drinks, milkshakes, fruit-flavoured carbonated water, you name it – except for water, our most necessary fluid.

Clear an atmosphere

We can clear an atmosphere in a room with our breath. Stand in the middle of a room and begin by breathing evenly and deeply. Imagine a fountain of white light above your head, and on each in-breath imagine pulling the light into your lungs. Then on each out-breath, imagine that same light pouring out of your mouth into the room and reaching every corner as you fill it with light. You can replace the white with any other colour you feel is appropriate for the room and your needs. Both indigo and violet are powerful colours for clearing and cleansing. You can visualise a violet or indigo flame soaring through the room to clear any negativity and dross.

Ease pain and discomfort

You can also breathe a colour into your hands to be used on your body to ease pain and discomfort. Place your hands gently cupping your mouth and then breathe the appropriate colour into them. As you are breathing the colour into your palms, continually affirm your colour choice. This will help you to focus. Once you are satisfied your palms are full of colour (this will take about three to five minutes), place your hands wherever you feel the discomfort in your body.

A headache can be eased very quickly, even migraines can be helped by using this method. Use sky blue, indigo or violet (the colour choice is yours), and cup the head with one palm across the brow and the other at the back of the head.

Peter cures his recurring headaches

Peter is 11 and from his first appointment he was like a little tin soldier, so stiff and upright. I observed his body language and colours as we spoke and I made notes. His parents had taken him to their GP as he was suffering from recurring headaches. No medical cause for these headaches had been found, and yet they continued to persist. As the session progressed, I suggested colour-breathing techniques for Peter to

follow both during the session and at home. As Peter lay on the couch, I covered him with coloured silks and started to work on him, holding his feet in my hands. Soothing music played in the background. It was only after 25 minutes that he started to relax.

Peter's parents were high achievers and he lived in the hothouse environment of a highly academic school that many other family members before him had attended. From the colours that were around him and the ones that he chose, it was obvious that Peter was a very creative child with seemingly little outlet for his creativity or free expression. At the end of the session I gave him instructions on how and when to carry out his colour exercises. I suggested to his parents that some fun creative pursuits during the week to counterbalance the homework regime would be a good idea. I didn't hear from them until three months later. A very happy voice greeted me on the end of the line, telling me that Peter had been carrying out his colour exercises every day, and had not had a headache for ten weeks. Peter no longer needed the painkillers for his headaches, and his parents had enrolled him in an after-school drama club that he was enjoying immensely. His mother excitedly told me that Peter was now much more relaxed and expressive and reminded me of something that had happened during our session.

While Peter was lying on the couch, he suddenly shot up and, stretching his neck, he looked towards me wide eyed, 'I can see blue every time I close my eyes and it doesn't go when I open and close them again. Where is it coming from?' Apparently Peter was continuing to see the blue colour every time he completed his breathing exercises and had his eyes closed. In the beginning, when he first began his daily colour exercises, the colour was very strong and definite, but his mother reported that the blue was beginning to fade and other colours were coming into his sight. When I put the phone down I smiled. I know colour allows us to be who we are. It feeds the parts that need nourishing and sky blue, amongst others, is the colour of inner peace, free expression and communication. With daily use of his colour exercises, Peter was rebalancing his colours and his energy system continued to feed back to him precisely the colours he needed.

Colour visualisation
• • • • • • • • • • •
Colour visualisation is one of many ways of using colour for deep relaxation.

Take the phone off the hook, make sure that you are warm and comfortable (you may find it best to be sitting as otherwise you may fall asleep), and loosen belts and tight clothing. Ensure you are breathing rhythmically and evenly, taking in long, deep, comfortable breaths. Hold your breath for a few moments, then release any tensions you may be holding on each out-breath. Experience a deep letting go, feel your shoulders, neck and body go limp. Breathe like this for a while as you become more comfortable and relaxed with each breath you take. You may need to adjust your sitting position as you gently and easily enter a relaxed state. Once you are ready to begin, try to imagine a slow running stream of clear water. Picture two or three large white stones in the stream and see the water washing gently past and around them. Breathe easily and effortlessly as you ease yourself into the picture in your inner sight. When you feel comfortable with this image, you will relax more and you may find other images coming forward in your mind's eye – flow with whatever comes up for you. Just notice what is coming into your inner sight, checking that you are breathing comfortably and rhythmically.

Think of the colour you want to work with. You may wish to imagine yourself in a garden, walking through a glorious profusion of coloured flowers. Imagine stopping to look at the ones that catch your eye. Roses are often people's first choice because of their heavenly perfume. Breathe in the perfume and colour of the flower. Imagining you are drinking in the colour and perfume with every breath you take.

You can work with colour visualisation easily and effortlessly by seeing the colour in any form that you can relate to. For example, when you close your eyes and see blue with your inner sight, imagine yourself walking through a field of bluebells, swimming in a turquoise warm sea with golden sands and palm trees, or see yourself on a tropical island standing under a waterfall. Allow your imagination to take off. With your eyes closed, imagine yourself flying through the blue sky, sailing on or swimming in the deep blue sea. Imagine the situation that would give you the most happiness and delight and that you would most like to find yourself in, keeping your colour choice as the main theme of the visualisation. Some find it helpful to imagine walking through nature, the warm sun on their back and the sound of running water in the background. If you find your thoughts wandering off, bring your attention back to your breath, feeling the warmth of your breath on your face and then ease yourself back in to your visualisation.

We can visualise ourselves and others as radiant, smiling and well,

surrounded by the colours of our choosing that we feel are most needed. This will greatly help in the healing process.

Patricia eases guilt – with Pink

Patricia knew that her mother was suffering feelings of guilt because of an ill-advised action over a family problem. Patricia visualised her mother well and surrounded in a beautiful rose pink. When Patricia next visited her mother she was surprised and delighted to see her wearing a deep pink blouse. It was a new colour choice for her. With the help of Patricia's absent healing and the vibration of rose pink, her mother was able to forgive herself.

Exploring your inner world

We now have a deeper understanding of the power of positive thoughts. Whatever we think of, we are in touch with immediately. An instant rapport is set up between us and the object of our thoughts. When we elevate our thoughts, we can bring about positive changes in ourselves and our lives.

The inner world that we build up through our thoughts has an impact on our bodies. We can direct our mind energy in a positive, creative and healing way, to benefit ourselves and others.

If we think loving, happy, healthy thoughts we attract loving, happy, healthy situations. Thinking more and more positive thoughts attracts positive energies. Our thoughts are alive and have the power to transform us. As we think, so we are. When a quiet and shy child reads stories of his hero, in his imagination he too becomes a hero and begins to take on his hero's mannerisms and character traits. His shyness alleviates and he begins to speak up and out both in class and amongst his peers. He identifies with a thought-energy and becomes that energy.

Everything we send out comes back in one form or another, so if you send out thoughts of joy, that's what you'll get back. When you think of someone that you know who may be in some kind of need, send them a thought of love and imagine them surrounded in a colour of your choice. Use white if you are unsure what colour to choose,

as white contains all the colours. Energies are speeding up and our awareness is opening; you may be going about your daily tasks when suddenly a thought of someone you haven't seen or heard from for a while pops into your head. Send them colour, think of them being surrounded with that colour.

The mind and our thought processes is one of the most important areas for light work. We believe no one is privy to our thoughts, yet our auric colours and vibrations are made up of our thoughts and emotions. If we feel uncomfortable when we see a smiling face or hear warm words and don't understand why, it's because our body sensors are picking up on these colour emanations that belie what our eyes are seeing or our ears are hearing. These feelings may not have a sinister base. It may be that the other person is trying to hide a deep hurt or current problem. We've all heard the words 'I'm fine' and know it's not true. Take the case of Sally.

Sally senses the truth

Sally was very young and inexperienced in love. She was besotted with a boyfriend. He said and did all the right things and treated her wonderfully, but she couldn't rid herself of the constant unsettled feeling in her stomach – in spite of her efforts to ignore it. One evening, in the bath, she asked the divine management for a symbol. It came quickly – a large black spider spinning a huge web. After that, she took off her rose-coloured glasses, stepped back and observed her boyfriend in a more detached way. For the first time, she saw his insincerity and then, a little while later, she found out that he had been two-timing her with someone else. From that moment on, she worked more closely with the divine management and asked for symbols earlier.

Asking for symbols

The symbol technique is not exclusive to relationships. You can use this method in every area of your life. Go quietly within and ask to be given a symbol that represents the situation or person. Always ask for the information to be given for your highest good and highest purpose and allow your mind to elevate to the highest source of light, the divine management. As you practice, you will se the doorway to your inner sight

begin to open and reveal information for both you and others. We are all given a piece of the elephant – no one is better informed than the other or has a monopoly on universal knowledge. You will be given all that you need for this time on your journey. You are so loved that nothing will be withheld from you. If you ensure that your words and actions agree with your intent, then you are well on the road to the bliss of inner knowing and peace.

Seeking solutions in your dreams

Keep a notepad beside your bed to record your dreams on awakening. It's so easy to forget dreams, and at first it can be difficult to understand the meaning of them. With an accurate record, you'll be able to see a pattern emerging, making it easier to understand the messages. Before sleeping, ask the divine management that you be given solutions to current problems in your sleep state. Solutions to events may come in the form of colours, dreams, ideas, symbols etc. Sometimes clear and at other times vague, watch for the cue cards. Your journal is your record of your journey. It is personal, and you may use it also as a daily journal of life's events. This way you can look back and see a thread running through your life and see how you have developed, grown and been guided, not only in the dream state but in your awake moments as well.

Robin receives a symbol

Every morning for a number of weeks, just before opening his eyes, Robin 'saw' a silver- and mauve-coloured emblem. Having no idea what it meant, he duly recorded it in his journal.

Robin was looking for a new job, a new challenge, but to date he had been unsuccessful. One evening a call came from a friend overseas. He told Robin about a new company that were recruiting; he felt that one of the positions in the company was ideal for Robin.

Robin's enthusiasm and sense of adventure was ignited. He applied for the post and when the application form came through the post, there at the top of the page was the company's logo. It was the exact emblem that Robin had been given each morning!

Working as a Healer

During healing sessions, my clients will often see certain colours while their eyes are closed and they're relaxing. These are usually the main colours being used within the session. In some cases, they see the colours with their eyes open. Others can see colours emanating from their own bodies. I am guided to say very little during a healing session, even though the room is ablaze and full of so much spiritual activity. When I am guided to give seeds of information, they act as a catalyst in assisting each person on their journey, so that they can realise their potential for growth and self-healing.

A healing session rebalances the client's colours, helping them to feel better, more relaxed and to see things more clearly and in a wider perspective, as well as seeing options that they were not able to see before. When we are emotionally involved with our clients, such as friends and family, we naturally want their healing to become instant and complete and we can become upset if this is not the case. By being so close, we can sometimes interfere with the transference of energy. It can be more difficult to distance ourselves from our emotions and work effectively as a clear channel. If you feel you are too close to be effective in a one to one, then step back and send the healing energy

from a distance. It is just as profound and effective for us all to work in this way – distance is no barrier. We can all send out healing thoughts to help and uplift another.

We also have to stay open to the reality that many roads lead to the same destination. When we have done all we can and played our part, we must be open to our clients choosing another way forward, or handing them over to another therapist for the next part of their healing journey. We need to avoid the trap of becoming possessive with our clients or mistakenly believing that our way is the only way. We are all unique and different and the many therapies that are in use exist to serve us all.

Unfortunately we are not able to save the world through our healing work and cannot prevent what is sometimes inevitable and meant to be. Some clients will be sent to us so that we can ease their passage onwards and nothing more. In these cases it can be a heartbreaking lesson to learn if you are just starting out or the client is very near and dear to you. Yet healing takes many forms and if we have played our part in making that transition to another dimension as peaceful as possible, then we have played an important role. With all healing, an upliftment of the mind and spirit is experienced by the receiver as well as a quietening of the mind, bringing a sense of peace. In some cases it brings an acceptance of an imminent passing.

Amy accepts and lets go

Amy was a beautiful waif-like woman, delicate and tiny in structure and with the most enormous blue eyes, open face and wide smile. I instantly took to her and the feeling was mutual, quickly leading to a close rapport. Amy had lived a blessed life. She came from a very happy and close family and had married her childhood sweetheart. They were very much in love and the best of friends and their two children made their lives complete. Amy adored her husband and two children and her husband's love for Amy shone on his face. Whenever he spoke about her, he sounded so proud. They had so much to give and share with each other and so much living to do. Yet Amy was dying. Towards the end, healing helped Amy accept that there was no reprieve for her and that it was her time to go. As her acceptance for her passing grew, so did her inner strength and she was able to help her husband and her children accept the inevitable.

Learning to step back

When we work from the heart centre and our heart is so open, it can be difficult to stand back and not get emotionally involved. We feel deeply and can so easily place ourselves in the other's shoes and feel their pain and discomfort. And when the healing session is finished, it can be difficult to cut off. I have found it necessary to take breaks from my healing work at regular times in my life. When my day's work is complete and I am faced with a full answer machine and a telephone that is constantly ringing, it's difficult not to be overwhelmed.

Looking back, these times have coincided with major changes in my life as I realised that I needed to put more energy into my own personal growth. It has always been difficult for me to pull back and it has caused many a long personal struggle to let go of my healing work, even for a short while, and to concentrate fully on myself and my own affairs. But I have always been forced to when I didn't listen to the messages coming to me loud and clear. I became exhausted and an exhausted healer is no good to anyone. I now give myself time to experience and enjoy the beauty of nature and take longer time out to appreciate the wonders of life.

Recently I went into a personal retreat. I disconnected the answering machine so the phone was only answered when I was in the house and when I was not otherwise engaged. I concentrated on myself, on my family and my inner work. I carried on regularly sending out the healing energy from my quiet space. Close friends despaired at first but, amazing as it seems, the management always ensured that I received any important calls at the right time. If someone was in particular need and couldn't get a reply, their face would come into my awareness, sometimes generating a call from me if I felt they needed personal contact. With others, I would sit quietly and send them colour and light. My senses were alert and open and everything was in perfect order. We always receive everything that we need.

You don't necessarily need to be in a one-to-one healing situation to help others. When out and about, a smile to another can make a difference to someone's day. At other times when your heart feels the pain of someone you pass in the street, at work or in the supermarket, send that person healing, loving thoughts. These methods take us only moments to carry out yet they can and do make a difference. Finally,

if you work with others, it is beneficial to receive regular treatments yourself from a therapist that you know and trust. When you are giving you need to redress the balance and be receiving regularly.

I'd like to finish this chapter by sharing with you some cases from my healing practice that show the amazing scope and power of colour healing work. Two of the cases take the form of letters from my clients.

Tony gets in touch with his spirit guide

Tony works in the complementary field. Over time he noticed his sensitivity was developing, yet he had a barrier accepting the presence and reality of angels, spirit guides, indeed anything that he couldn't see or touch. He was at a stage in his life where he felt that he needed to see something in order to accept its existence. He came to see me on recommendation. He was very direct and we talked for a long time before the session began. I never know before I begin working how any session will unfold. This particular session took its course and, as normal, a lot of activity took place from the management. Towards the end of the session, an Eastern man stepped forward and made himself 'seen' to me very clearly. He wanted to tell Tony to clear the rug he was given from the loft and either use it or give it away. He then asked Tony to sit up.

I duly passed on what I had been given to Tony, who was taken aback as the rug was a gift that he had not used and it had been rolled up and stored in the loft. I had his attention! He sat up and I was then guided to ask Tony to look at his feet and lower legs. As I worked, he was able to see the yellow and violet light coming from my hands on to and colouring his skin. In what seemed like an age, he put his hands where I was working and felt and saw the colours on his hands. It was a very moving experience that left an indelible mark on both of us. Tony had been given an experience that he couldn't deny and that could not be taken away from him.

Olivia finds new hope

'It is now exactly one year since I first went to June for healing. In writing this, I have looked back to the state I was in a year ago, and I

can hardly believe that I am the same person who went to seek help so nervously and despairingly.

'I heard of June through a contact number given to me by the Bristol Cancer Help Centre. I had been told by my doctor five months before that I had breast cancer for the second time, and that it looked as if this time it had spread to my lymph glands. I knew for sure that I did not want the surgery and radiotherapy that are normally given, but I was running out of alternatives. I was very hopeful that a stay at Bristol would help me recover, and they advised me to have as much healing as I could before going there. All I can remember of this time is that I felt ill, exhausted and unable to cope with daily life.

'My life up to that point had been full of difficulties, and I do clearly remember feeling that I simply could not take any more grief.

'From my first appointment with June, I found I had been given the seeds of a new energy and, most importantly, a definite feeling of hope and confidence that I would get through this. I had always felt that the problem was in my mind rather than in my body, and I felt for the first time that this was being addressed.

'There have been some momentous happenings as a result of the healing. My energy has returned, along with a sense of excitement about the future. I know that I am well, and do not fear illness. Perhaps even more valuable to me is a new feeling of confidence and awareness that is enabling me to restructure my life along the lines that I have always yearned for, yet never been able to achieve. I feel free at last to be myself.

'I am slowly becoming aware of the significance of colours, and finding great comfort from being surrounded by them. I look forward to learning a lot more in this direction, for it is an area that is growing in importance to my life. It has taken a long time for me to be able to see colours in healing, and I will never forget the first time I saw a cloud of magenta rising from my body. I have been left awestruck by the experience.

'When I look back over the past year, I find it hard to believe the difference between then and now. It is like being handed back your life, only it is not the old one that was so full of pain and grief, but a new one full of promise and learning. I know beyond a shadow of doubt that the way June gives healing, and the energies that she is able to transmit, are responsible for this. I feel deeply privileged to have been the recipient of this most wonderful healing.'

Mary experiences a turning point

'I first learned I had cancer of the colon in 1996. The news was devastating – I couldn't believe this was happening to me. My first thoughts were to look for someone to help me. As a practising homeopath I turned to complementary medicine for help, as well as help from the medical profession. I telephoned the Bristol Cancer Help Centre. I had read about how they worked with people with cancer and how they addressed the spiritual as well as the physical needs of the patients. I thought it would be a good place to start.

'They were very kind and understanding and after booking a week's course after the operation for myself and my husband, they asked if I would like to visit a healer.

'I hadn't thought of this but said 'yes,' and they gave me the name of a local healer. I made an appointment and had my first meeting with June.

'This meeting had a profound effect on me. June told me many things about myself and all of them were true. At the end of the session she said something had shifted but I only felt sad and tearful although much more confident. June said I would make old bones. She also told me not to fear the hospitals and doctors.

'It was a time of great love and support from my family and friends. I felt that this crisis was meant to be and that only good would come out of it.

'The next day an amazing thing happened to me while I was lying in the bath. I closed my eyes and saw the colour green, which is a healing colour. It changed to yellow, which represents the solar plexus and is to do with self-worth, then to red. The red square moved across my vision, to the right. This was the part of the colon that was cancerous. Then it eventually moved back again and stayed in the centre, very bright, for a long time. Eventually it faded. This left me feeling very excited and confident and well.

'I had the operation to remove part of my colon and was relieved to be told by the doctors that the cancer had not spread to the lymph glands or to the liver. I decided not to have chemotherapy treatment and the doctors didn't insist because the cancer had not spread. So I was on the road to recovery.

'I recovered my health very quickly and in April I visited June again. I

had a wonderful session with her and she told me that the colours I had
seen just before the operation had contained the cancer and prevented it
from spreading.

'In May, I saw June again. At the end of the session she told me I
was well. I was so surprised and pleased and relieved and many other
emotions. I went home and told my husband and we shed a few tears of
relief and then went out to celebrate. One year later at my check-up with
the hospital doctor, he told me I was well. But I knew already.

'Nearly three years on I am very fit and well and able to enjoy my
life to the full. I now have two grandchildren, both born after my cancer
operation.

'Having cancer has been a turning point in my life and made me
think about my attitude to life and about valuing myself and how very
important this is for my physical and spiritual health. Making changes in
our lives is difficult and needs support from people close to us and from
caring professionals, but ultimately it is up to us as individuals to make
the right choices for ourselves.'

Colour and Complementary Therapies

Aromatherapy

I have perfumed my bed with myrhh, aloe and cinnamon.
Come, let us take our fill of love till morning.

<div align="right">PROVERBS 7, 17-18</div>

Colour and essential oils are a profound healing combination. Use excellent oils from a reliable source, organic oils being the first choice. An essential oil that is chemically reconstituted can be toxic and therefore dangerous. It is far better not to use an oil at all than use an inferior one. Use sparingly to obtain the greatest effect. Store your oils in a cool dark place away from sunlight and bright lights. Do not buy or use essential oils that have been stored in plastic containers, as they should always be sold in glass bottles. Ensure that the top is airtight.

Essential oils carry contra-indications and you should consult

an aromatherapist before using if you are pregnant, suffer from fits or are using the oils on babies or children. All oils are antibacterial, antifungal and antiseptic but some are stronger than others. When you mix different oils, the strength of the oils in a synergistic blend becomes more powerful and it is advisable not to use more than four in any one blend.

Be led by your senses when choosing an essential oil. If your body rejects a smell, try another one. There are hundreds to choose from and many can be used for the same purpose, so your choice will in no way limit you. Children are very sensitive to the smell of the oils and will immediately tell you if they like or dislike one. As the bond between mother and baby is very strong, a mother will make the correct choice for her baby, especially if she is breastfeeding.

Ways of using essential oils

At home you can use oils in a diffuser, a burner, in the bath, in a massage oil and in numerous other ways to benefit all the family. During illness, the use of essential oils will protect the health of the rest of the family from airborne infection and bacteria. It is interesting to note that during the Great Plague (1664-6), the flower sellers and perfumiers didn't fall ill. This is just one instance in history where the plant kingdom protected human life. Therapists can benefit from burning frankincense or myrrh in their therapy room. These two oils are marvellous energy cleansers and protectors and will help prevent the therapist from picking up 'stuff' from the client.

When using essential oils in the bath, first run the water and add your essential oils (10 drops maximum per bath) just before stepping in. Agitate the water to help release the aroma, and then enjoy a lovely long soak. Don't add the oils while the bath is running because although the bathroom will smell divine, the oil will evaporate and you won't get the full benefit of absorbing it.

Burners for essential oils can be purchased from many outlets. Choose a burner with a deep bowl on the top so that you won't have to keep remembering to fill it up. This can be a nuisance and detract from the true benefits of an efficient burner. When you use a burner, pour hot water into the bowl on top and add three to four drops of essential oil. Place a nightlight underneath and leave it in a safe place away from children's inquisitive hands. Essential oils can also be put on to cotton-wool balls and

placed behind radiators. This is a safe choice if you don't want to leave a burner alight.

To help a baby to sleep, take a 1-pint (0.5 litre) Pyrex bowl and three quarters fill it with hot water. Add two drops of Roman chamomile and two drops of lavender and place the bowl under the cot. (Roman chamomile and lavender carry no contra-indications in this recommended dose.) Leave it there for half an hour and then remove the bowl from the room before placing the baby in the cot. The atmosphere will have been infused with what I call the 'baby combination'. A gentle profusion of oil is all that is needed or the reverse of the benefits that you are trying to achieve will occur and the baby will become over stimulated.

Lavender is a wonderful general essential oil that every household should have in stock. Along with tea tree essential oil, it is the only essential oil that can be used neat on the skin although as with all essential oils you must keep them away from the eyes as they will burn and sting.

For toddlers through to adults you can put a drop of lavender oil on to the edge of the pillow for a good night's rest. Again use sparingly as less is more and too much will have the reverse of the effect required. Use lavender oil to freshen a mattress – a drop on each corner and two to four drops scattered over the mattress (two for a single and four for a double) once a month when you turn it over. This will ensure that the mattress stays fresh and will deter moths, mites and bugs.

Basil oil is wonderful to use in the car for long journeys. One or two drops sprinkled on the carpet in the car will keep you alert on long trips and in some cases has been known to prevent travel sickness.

Aromatherapy massage

All of us love massage. Try gently massaging one drop of lavender or Roman chamomile in 15ml of almond oil onto a restless baby's feet or back. No special talent is required for massaging our loved ones, a gentle loving hand is the only essential needed.

When massaging stay away from the face, hands and arms and anywhere where the baby can touch the oil and transfer it to his or her eyes or mouth. Use the leftover oil yourself after a bath or shower.

Pure essential oil of rose can be made into a glorious body oil. For adults use five drops per 20ml of carrier oil (almond oil for example). You can try sitting with your partner, one each end of the bed or sofa, and massage

each other's feet with a rose oil blend. Rose is known as the love oil and the sensuous combination of massage and smell of the oil can do wonders for your relationship!

Pest deterrents
• • • • • • • • •

Since living in the country I have had regular evening visits from field mice. I wanted my home to myself but I wanted to keep them away humanely. I used eucalyptus oil soaked into a cotton-wool ball and placed the cotton balls where I knew the mice were entering. They cannot stand the smell of this oil and immediately found somewhere else to visit. My family also benefited from the clear, fresh smell of the eucalyptus. It is excellent to use in a burner when anyone in the household has a cold or needs to ease their airways.

You can also use eucalyptus as a hair rinse to combat lice. Put 1 pint (0.5 litre) in a Pyrex jug. Stir well with a wooden spoon and with the eyes covered, gently and slowly pour through the hair. Comb through and leave to dry. This will also deter re-infection.

Julia replenishes her energy

Julia worked long hours in the city juggling a high-flying career with a family. Most mornings she woke up feeling tired and with no get up and go. The fact that her energy had been gradually depleting over the past few months was causing her some concern. Her tiredness also put her on a short fuse – both at work and at home. This led to feelings of guilt where her children were concerned, as she felt time spent with them should be quality time. Past tried and tested treats such as beauty treatments, massages, retail therapy and even the odd weekend break away only temporarily helped her diminishing energy. She couldn't work out why she wasn't coping. She had coped well when the children went through their sleepless-night stage, and now that she was getting sufficient sleep, why was she feeling so listless and drained? She needed to act to stem the flow of her decreasing vitality and stamina. A colleague Julia respected had completed a course of colour treatments and recommended that she book an appointment. Julia had her doubts. She contacted her doctor who could find no reason for her lethargic state and put it down to stress and pressure of work. She carried on for

a while longer until curiosity got the better of her, and she booked an appointment.

From her first appointment, Julia struggled with her exercises. She persevered, however, and once she let go of her reservations, carried out the exercises between treatments and applied her colour knowledge to every area of her life, she began to feel energised. As time went on she began to feel more energised and became an enthusiastic colour convert. One of the many ways that Julia now uses colour is to put an hour aside for herself in the evening. In the 24-hour clock, this is the violet time and she prepares a bath with one of the violet essential oils (see page 90), her favourite being frankincense. Julia lights candles to create a relaxing atmosphere and, as she lies in the bath soaking, she breathes in the aroma linking her to the colour of the essential oil. On each inhalation she breathes violet into her being, visualising it permeating every part of her. On each exhalation she experiences a deep letting go. Julia does this for as long as she needs to feel connected to her colour choice and totally relaxed.

Once she feels relaxed and at peace, Julia concentrates on her heart centre, resting her two hands gently on her heart as she breathes easily and effortlessly. She silently repeats an affirmation of her choice. Then to complete the treatment, Julia imagines herself bathed in golden light for a few moments to balance the use of the violet ray. I also suggested to Julia that she hum the OM mantra before going to sleep. The OM mantra is spoken or sung as it sounds with the emphasis on the 'M'. This mystic syllable is considered to be the most sacred mantra, meaning 'Amen' or 'so be it'. As the sound resonates through Julia's body, she says she feels a deep resonance with the sound, and combined with the incorporation of colour in her life, has slept better than she can remember. Her husband confirms that when Julia sleeps, she hardly moves and it is not unusual to find her in exactly the same spot in the morning. She awakes refreshed and energised before the alarm goes off. It gives Julia great joy to relay to me the innovative ways that she is bringing the benefits of colour into both her own and her family's life.

Essential oils and their appropriate colours

Following is a list of which essential oils link to which colour.

RED	Cedarwood, rose, geranium, rosemary, black pepper, red cinnamon, clover.
ORANGE	Mandarin, juniper, clary sage, ylang ylang, jasmine, calendula, neroli.
YELLOW	Lemon, basil, bergamot, grapefruit, camphor, lemongrass.
GREEN	Geranium, rose, Douglas fir, pine, eucalyptus.
SKY BLUE	Roman chamomile, German chamomile, marjoram.
INDIGO	Lavender, sandalwood, marigold.
VIOLET	Frankincense, myrrh, white spruce, viola.
PINK	Rose otto, rose absolute.

Perfumed plants and flowers

'If you take a flower in your hand and really look at it, it's your world for the moment.'

Georgia O'Keefe

Plants were the earliest form of life on our earth. No human or animal life could live without the plant kingdom. It took our ancestors years to learn to differentiate between poisonous and non-poisonous plants. Healing recipes and methods were created through trial and error and were passed down through the spoken word from generation to generation in many diverse cultures. It is heartwarming to see the revival of this trend as we go back to the abundant healing garden of nature for more and more of our 'cures'.

Perfumed plants and flowers are wonderful and absolute in their ability to give off their healing vibration and clear any negativity in the atmosphere. We all feel uplifted amongst flowers and a vase of freshly cut flowers can lift and transform the atmosphere of a room. Flowers and plants offer their fruits and oils freely for both healing and upliftment. The combination of colour and perfume arouses our senses and is an effective way to inspire and affect our mood. Use your colour knowledge with flowers next time you buy or send some. Think colour first.

RED	For passion and action. Red flowers demand attention and declare the giver's intensity of emotion.
ORANGE	Warm, glowing orange cheers us up. It makes us feel content, happy and joyful. Orange flowers remind us of the joys of life.
YELLOW	Enthusiastically welcoming. Happy sunny yellow flowers seem to shout 'Good morning! Have a nice day!'
GREEN	Calming and serene. Green foliage or flowers are relaxing and strengthening.
BLUE	Peaceful, restful and healing. A bunch of blue flowers can elevate our thoughts.
VIOLET	Inspires us to be and reflect. The perfect choice for someone who is convalescing.
PINK	Love, gentleness. Pink flowers are from the heart.
WHITE	Mirrors the pure qualities of the other colours and great to include with other colours in an arrangement.

Nature provides a wonderfully inspiring display of colours, sometimes in startling combinations. Next time you are out, notice the way in which she grabs our attention; she is always hinting at us to become more experimental in our own colour combinations.

We just need to observe and bring ourselves back to our natural rhythms and then we can tap into and use the knowledge she offers us so freely.

Herbal medicine

Herbs are another example of nature's bountiful harvest. Every plant has its uses and everything in nature is a form of medicine if we know how to recognise it and use it. And like essential oils, herbs have their own colour associations. We are growing our own herbs more and more these days and using them in our cooking. When drying your own herbs, collect the ones you're going to use in the morning as this is when they contain the highest proportion of live essences and you can preserve their unique and valuable properties. Bunches of herbs

can be tied and hung to dry in the kitchen, where the air can circulate freely. When thoroughly dried they can be stored whole in glass jars, one jar for each type. Do not grind or crush the herbs until you come to use them since their live essence quickly loses its strength. As with essential oils, always remember that less is more and use sparingly. Date all stored dried herbs as they last for a maximum of nine months. Some older recorded recommendations for storing herbs even suggest we store them no longer than three months.

Making your own pot pourri

Try making your own pot pourri or even a herb pillow. A quick way to dry your flowers and herbs is to place them on to a plate and put the plate in the microwave with an egg cup of water for five minutes on full power. You can than store them or place them in a bowl and sprinkle an essential oil over for pot pourri or stuff a small pillowcase and use as a herb pillow. Again, sprinkle the contents with essential oil.

Herbs and their appropriate colours

Here are some examples of herbs and their colours. It is not exhaustive and there are many more uses for them than are listed here. Consult a herbalist for treatment with herbs as some carry contra-indications and are very powerful.

COLOUR	HERB	USES
RED	Compatum:	Loosens joints and improves circulation.
	Hawthorn:	Red berries can be chewed or made into jelly to increase circulation and alleviate hardening of the arteries.
	Red clover:	Effective for the menopause.
	Nasturtium:	Used to treat urinary disorders. Use as poultice for bolts and sores. Leaves are edible in salads.

ORANGE	Pasque:	Happy herbs, good for depression and expression of emotions.
	Toadflax:	Inner cleanser.
	Calendula:	Antifungal.
YELLOW	Sowthistle:	Use leaf infusions for inner cleanliness.
	Tansy:	Not to be eaten. Use as a poultice for varicose veins. Hang in kitchen to deter flies.
	Feverfew:	Aids flow of fluids in the body.
	Lemon verbena:	Excellent for pot pourri as it retains its scent for up to 18 months. Leaves can flavour tea and jam. An internal cleanser, it is good for flatulence and nausea.
GREEN	Angelica:	General balancer and good pick-me-up. Regulates blood pressure.
	Foxglove:	Used for heart conditions. Very powerful and only to be used on prescription from a herbalist.
	Golden seal:	Excellent rebalancer.
	Chervil:	Regulates blood pressure.
SKY BLUE	Borage:	For throat and upper chest. Has a blue five-star flower. Leaves a refreshing cucumber taste when used in drinks.
	Forget-me-not:	Healing abilities. Useful in times of bereavement.
INDIGO	Eyebright:	Remedy for the eyes in lotion form or taken internally.
	Rue:	Known as a great protector against negativity.
	Lavender:	Essential for a pot pourri. Purifier and antiseptic. Deters moths.
	Sage:	Many powerful uses. Excellent for hot flushes during menopause. Liver cleanser.

VIOLET	Violet:	Excellent all-rounder.
	Sweet Violet:	Pot pourri, cake decorations, puddings. Can be used for headaches, vertigo and to clear mental confusion.
	Heartsease:	An excellent all-rounder and purifier.
	Self heal:	For spiritual healing. Used to inspire confidence in self.
PINK	Hollyhock:	Prevents miscarriage, gentle reharmoniser.
	Mallow:	A cure all. Regeneration.
WHITE	Garlic:	Reduces cholesterol in blood. Great purifier.
	Chamomile:	Sensitivity, equilibrium.

Crystals

Crystals are very versatile and are used in watches, televisions, radios, satellite communications and so on. They have been used as far back as antiquity by many different cultures for many different purposes.

I believe that crystals in the home are a necessity. They are beautiful to look at and brighten up, lighten up and colour any space where they are placed. If we programme them (see below), they can protect, balance and harmonise – healing both the atmosphere and ourselves. The three crystals that you need to form the basis of your collection are white rock quartz, rose quartz and amethyst. When you link their healing qualities with colour, you have an aesthetically pleasing powerhouse at your disposal.

Different ways of using crystals

You can put crystals in your drinking water to energise it and pass on the qualities of both the crystal and the colour. Water energised in this way also keeps plants strong and flowers fresh. An ailing plant can be given a new lease of life if you plant a small quartz crystal close to its roots and leave it there until you see the strength and life returning, at which time it can

be removed. When filling your vase with fresh water and before placing the flowers into the vase, place a small piece of rock crystal at the bottom of the vase. This will help to keep the flowers fresher for longer. A piece of rock crystal and malachite placed near a computer will help disperse the negative energy emitted. You can purchase crystals to wear as pendants, rings and earrings and programme them for healing and protection, although it is advisable to regularly change the crystal that you wear. Wearing the same type of crystal all of the time can create an imbalance and even cause leakages in the aura. As in all things, a balance is needed. An imbalance occurs if you stay with one colour for too long. And be aware that if the crystal you are wearing is pointing downwards, it is helping to earth you. If it is pointing upwards, it is linking you with the higher energies.

Buying, cleaning and programming crystals

When you purchase your crystals, let them choose you. Stand quietly in the shop and cast your gaze over them all. One or more will bring your attention to them and will stand out from the rest. Nothing is by chance and you have now been chosen. Go over and hold them. Look at their beauty, cut and colour and feel the energy they are radiating. Some will feel tingly, even warm, and may send waves of energy up your arms; others may feel cool yet emanate a definite power of their own.

Once you get your crystals home, you should wash and cleanse them. You can cover and leave them in water for 24 hours with a few drops of Bach Rescue Remedy added, or soak them in a fresh, still spring water with a teaspoon of sea salt added. After 24 hours, lift them out and stand them on tissue paper or kitchen towel and allow them to dry naturally. When they are dry, they are ready to be programmed.

Programme each crystal one at a time by holding it in your left hand, centring yourself quietly and asking that the light radiate through you. Use your imagination and see an image of a fountain of light above your head coming from the highest light source and imagine this pouring through the top of your head, throughout your body and then pouring into your left hand and the crystal. When you feel comfortable that this has been achieved, place the crystal into your right hand and decide what you want this crystal to do for you. For example, you might want it to radiate love, healing and light within the home, to benefit all who live there. Once programmed for this purpose, place the crystal in the main living room or

entrance hall by the stairs.

For absent healing, name the person or animal in the programming, then place the crystal next to or over a photograph of them. If you do not possess a photograph you can place the crystal over their handwriting, or a piece of hair or fur. In general when you are sending colour healing thoughts to someone, you can place a crystal over their photograph or handwriting to further reinforce the healing energy.

Cleansing an atmosphere
• • • • • • • • • • • • • • • •

When cleansing an atmosphere, programme your crystal and leave it to do its 'work' in the room that needs clearing. When moving house it is advantageous to programme a large piece of crystal to cleanse the atmosphere of your new home, clearing any energetic baggage that may have been left behind by the previous owners. On the day of the move, programme your crystal and place it in the most central point of the home, on the ground floor. A large piece of white rock quartz is the perfect choice for this purpose. As you are programming the crystal you will be asking that it clears and cleanses the atmosphere within this building and absorbs any negative energy. The simpler the programming the better. You can use your own words for your own needs. Once you are satisfied the atmosphere has been cleared (this may take a fortnight) then you can cleanse and reprogramme your crystal for another use. An example would be, 'I programme you for love and healing' so that love and harmony emanate from your crystal, propelling a loving, healing energy throughout the home. You may wish to finish your programming with the words, 'in the light, for the light and of the light'. Then place the crystal where you will benefit from its colour and energy.

The pink rose glow of rose quartz is very soothing. Pink is the loving colour of the heart, the colour of unconditional love and the colour that relaxes the muscles and is accompanied by a feeling of a deep letting go. It is a good choice for the living room or a bedroom, especially children's bedrooms or a nursery. Rose quartz under the bed aids a restful night's sleep. The healing energy of the violet amethyst can be used anywhere in the home, and the purity and versatility of the white rock quartz make these three an excellent place to start your discovery of the wonders and benefits of the crystal kingdom.

Children and animals
● ● ● ● ● ● ● ● ● ● ●

Children love to look at and touch crystals. Let them have their own
small pieces that you can programme to help and assist them. Use your
imagination and tailor the programming to suit your family's needs.
Remember to regularly cleanse your crystals in the way shown above. You
can place a programmed crystal in your animal's bedding as well as a small
piece in their drinking water. Put smaller pieces of programmed rose quartz,
rock quartz or amethyst on the windowsills around the home to catch the
sunlight and send out their healing protective qualities.

Healing tools
● ● ● ● ● ● ● ●

Not only are crystals visually stunning and a good talking point with
visitors, they are also healing tools that we can all use. You may place the
programmed crystals on your chakra centres to cleanse and clear your
centres, or even to boost them. Amethyst is a gentle, soft vibration and
soothes the whole system. Place a piece of violet amethyst or rose quartz
on your stomach over the navel when you feel tense, tired and lethargic.
Breathing and chest problems can be helped by programming your amethyst
and laying it on the chest. Amethyst rose quartz and white rock quartz can
be used anywhere on the body for any problem in fact. Be guided by your
own choice. Once programmed the crystals will work gently and effectively.
The gentle pink vibration of rose quartz can aid in all fertility problems,
menstrual problems and placed over the heart centre can balance and
harmonise the whole system.

Nutrition – a rainbow on your plate

If we don't eat the correct food, we cannot expect to operate at our
optimum level of energy, have the stamina and mental energy to
keep functioning, and the ability to absorb all that our bodies need to
maintain us in good health. We will eventually become unbalanced,
placing a strain on one or more parts of our systems and becoming
unwell.

Food is our body's fuel, and to function at our best we need the very
best. It is far more beneficial to purchase a smaller amount of more

expensive fresh food and reap the live goodness and purity of that food, than to buy cheaper produce that may contain unnatural sprays and chemicals. Fortunately organic food is becoming more popular and easier to find; small organic delivery companies are sprouting up all over the country.

Interest in nutrition has increased dramatically too. Consumers are now reading food labels with knowledge and understanding of the ingredients listed. Many theories exist for the optimum way that we should eat and combine our food for dieting and for our general wellbeing. Experiment and find what works best for you, as we are all unique and what suits one may not suit another. Some find food combining to be very beneficial, others prefer raw food whilst some prefer mostly cooked. Some eat whatever they enjoy, whenever they want! Food can also be linked to the blood, i.e. certain foods for certain blood groups.

When we are in tune with our body and can hear the subtle colour messages it sends us, we are then able to feed ourselves exactly what we need. Most people are generating too much acid, with stress pumping adrenalin around the body. Not eating on the run sounds obvious but, sadly, too many people do just that. When we have a deadline to meet, sitting down and eating in a healthy and relaxed way goes out of the window. Instead we grab a quick snack believing that we are saving time. Unfortunately, this is not the case. If we were to make an event of eating more colourfully, in a relaxed fashion, taking the time to enjoy and savour each mouthful, we would be revitalised and refreshed and have the energy to confront the deadlines we are subject to.

Any recipe prepared with love will taste sweeter and more delicious. Think how the food that you're preparing will nourish and feed your loved ones and you'll be surprised at the difference. Try not to prepare fresh food in advance because as soon as you cut fresh food, some of the live substance begins to leave it. This has been shown through research with Kirlian photography (see page 26). There are some fascinating photographs that depict this process – the loss of energy looking like a flash of light. Choose and pick the freshest food you can find and do not store it for too long. In an ideal world fresh vegetables and fruit are picked and brought straight to the table.

If you have been taking vitamins for a long period, unless medically

prescribed, you may cease to find any benefits. Take them occasionally, stop and review how you feel. Try to replace them with food intake and take the natural approach whenever possible.

Chewing is the first stage of the digestive process. If we chew our food thoroughly, we release the life-giving essences into our beings. These essences feed the subtle body before nourishing the physical body. You may find it helpful to leave the table thinking that you could always eat a little more, as this has been found to be more beneficial than overloading the system. When we eat more than we need to, energy that we could have used more positively elsewhere goes instead into alleviating our overloaded bodies. Overeating makes us feel heavy and lethargic, whereas eating more moderately gives us energy and vitality.

Fasting

Fasting for 24 hours every so often gives us clarity and refreshes our whole system. Eat only fruit two days before the fast. You can eat as much as you want and as many varieties of fruit as you wish. This cleanses and clears the system in preparation for the 24-hour fast. During the three-day period only drink hot water – you may add a slice of lemon if you wish and a little honey to sweeten. If you feel nauseous or have a headache during the fast, gently sip the hot water and lemon to flush the impurities out of your system. During and after the three days all of your senses are more open and it's amazing how much more information you receive once your physical and subtle bodies have been cleansed and cleared. You will feel very clear mentally and physically and you'll feel a renewed sharpness and mental agility.

Preparing colourful meals

Prepare all of your food colourfully. A plate of food with a minimum of five different coloured foods taken from both ends of the spectrum will ensure you are eating a balanced diet full of vitamins, minerals and nutrients.

We now know that red, orange and yellow fruit and vegetables are high in antioxidants that help clear the body of toxins. Interestingly, in colour therapy the magnetic colours, red, orange and yellow, keep us earthed and grounded. Green is the most favoured colour in the vegetable kingdom and in colour therapy is the great balancer.

Next time you prepare a meal, observe your colour scheme. Yellow, green and red peppers, tomatoes, oranges, carrots, celery sticks, aubergines, cauliflowers, parsnips, peas and beans, and red cabbages can all be combined in different ways. Stretch your imagination and use as many colours in each meal as possible. Meal times should be a mouth-watering display of colour and aroma, massaging and delighting our senses of sight, smell and taste. Our levels of vitality and energy are linked with what we eat and so we need to be selective and purchase the best, freshest and most colourful foods, and then enjoy a gastronomic feast of colour and goodness.

Using the best ingredients and adding a little bit of what you fancy is your best recipe. Try the five plus greens method for a healthy diet. At each meal choose any three foods from the magnetic colours (see page 39) or vice versa, adding as many from the green selection as you like. This will provide you with a rainbow of goodness on a plate – a joy to behold and to eat. (Bread may be eaten with each meal.) We don't have to count calories or weigh our portions to regulate our weight or to receive all the vitamins, nutrients and minerals we require. All we need to do is follow nature's colour code. There's an additional benefit too. Children love colour, and the colour of the food on their plates is no exception. If their plates are bursting with coloured goodness, they usually demolish each plateful. The next generation is in our care; we can make a difference by colouring their lives.

Food and Colour Associations

The following lists will help you think about the colour in your food.

RED FOODS
James, conserves, lean red meat, offal, barley, tomatoes, red peppers, radishes, lentils, kidney beans, red onions, beetroot, chilli peppers, red-skinned potatoes, plums, watermelons, rhubarb, red apples,

raspberries, cranberries, red cherries, red grapes, strawberries, cloves, cayenne pepper and various spices.

ORANGE FOODS
Honey, sugar, egg yolks, smoked fish, buckwheat, millet, lentils, grains, pasta, baked beans, broad beans, pumpkins and pumpkin seeds, swedes, sweet potatoes, carrots, orange peppers, butternut squash, all potatoes apart from red-skinned, shitake mushrooms, tahini, paw paw, the majority of citrus fruits, oranges, apricots, peaches, mangoes, guava, ginseng, nutmeg, ginger, turmeric, coriander and many other spices.

YELLOW FOODS
Butter, sunflower seeds and oil, eggs, cheese, cashew nuts, corn, maize, wholegrains, rice, golden grains, cornmeal, couscous, alfalfa, soya beans, yellow lentils and spices, yellow peas, yellow peppers, pineapples, bananas, lemons, melon and grapefruit.

GREEN FOODS
Natural yoghurt, Greek yoghurt, olives and olive oil, all nuts, tinned sardines, tuna, tofu, quinoa, beans, cabbage, peas, green peppers, Brussels sprouts, celery, spring greens, asparagus, curly kale, broccoli, haricot beans, mung beans, green lentils and dried peas, lettuce, courgettes, avocados, artichokes, cucumber, seaweed, watercress, okra, green grapes, kiwi fruit, limes, mint, parsley and numerous other herbs, amaranth seeds, fennel, and caraway seeds.

BLUE FOODS
Molasses, treacle, fish (all types except shellfish), white meat, broccoli (tender young tops), black beans, mushrooms, mung beans, aduki beans, beetroot, blueberries, blackberries, dark cherries, dates, raisins, prunes, sultanas, currants, and spices.

VIOLET FOODS
All shellfish, oats, wheat, bran, rye, linseed, fenugreek, soya, numerous types of beans and pulses, aubergines, purple cabbage, onions, garlic, globe artichokes, purple grapes, figs and dates.

Vitamins and minerals

Even vitamins and minerals have their own colour, as do cell salts.

VITAMINS	
Vitamin A	Violet
Vitamin B	Red
Vitamin C	Orange
Vitamin D	Yellow
Vitamin E	Green
Vitamin F	Blue

MINERALS	
Calcium	Green
Chlorine	Yellow
Fluorine	Green
Iodine	Blue
Iron	Red
Magnesium	Orange
Manganese	Blue
Phosphorus	Red
Potassium	Red
Silicon	Violet
Sodium	Yellow
Sulphur	Green
Zinc	Orange

CELL SALTS	
Calc Sulph	Indigo
Calc Sulph	Sky blue
Ferr Phos	Magenta
Kali Flur	Yellow
Kali Mur	Orange
Kali Phos	Red
Kali Sulph	Yellow
Mag Phos	Yellow
Nat Mur	Violet
Nat Phos	Green
Nat Sulph	Orange
Potassium	Violet
Silica	Sky blue

10

Music, Sound and Movement

There will come a time when a diseased condition of the soul life will not be described as it is today by the psychologists, but it will be spoken in musical terms, as one would speak, for instance, of a piano that was out of tune.
RUDOLPH STEINER

Music and colour

The first efforts to show links between colours and tones are ancient and include schools of thought from ancient India and Greece. One of the first attempts to show these links was made by Ptolemy, a 2nd-century astronomer from Alexandria. Much later, Sir Isaac Newton tried to prove there were physical and mental associations between pitch and colour. Einstein himself, amongst other reputed physicists, noted the fact that matter is thought, vibrating at a lower frequency.

The actual difference between one element and another is just a difference in vibrational frequency, as are notes of a musical scale,

colour and light. Some Indian traditions refer to the chakras as lotuses, each with a different number of petals. This number denotes the frequency of each chakra, because a different number of petals or spokes are visible to the eye depending on the speed of rotation or vibration. Similarly the colour emanating from each chakra is dependent upon its rotatory speed.

Colours are different frequencies of light vibrating. Therefore each chakra has a relative sound to which it will respond. Indian teachings give each chakra a Sanskrit letter and a sound. From the base chakra to the crown, Indian tradition gives us this scale of vibrations:

Base	4
Sacral	6
Solar plexus	10
Heart	12
Throat	16
Third eye	96
Crown	960

This indicates that the spirit manifests in the crown chakra, and matter (in its densest form) manifests in the base chakra. Each intermediate chakra from the crown down increases in density as the life force descends in the body. This densification could be compared to the vibratory effect produced by stringed instruments. When the string vibrates slowly, deep notes are heard. Higher notes are produced when the string vibrates at a faster rate. Therefore, when the life force vibrates at greater speed, finer levels of consciousness are achieved. Lower rotations represent the more material levels within.

For as long as records go back, ancient cultures have been using sound for healing purposes. In the 6th century, Pythagoras perceived the universe as a musical instrument, as governed by sound. He agreed with the ancient esoteric schools that called the sound of the universe the music of the spheres. In ancient esoteric schools the music of the spheres was known and documented and was heard by those who were highly sensitive and attuned to the colour rays.

Pythagoras, like many others past and present, knew that music or

sound can either be beneficial and recharge our systems or imbalance, tire and deplete us. Recent research has shown that sound can slow down the vibrational rate, hence the growth of molecules to either stimulate healthy cells or heal others. Blood cells have been found to change colour and shape depending on sound frequencies used. The correct notes can be as therapeutic as inappropriate ones can be damaging. A lot of exciting work is now being carried out in this field, and as we swiftly enter the Aquarian Age and the violet ray of humankind's higher consciousness, many ancient discoveries will be rediscovered and put into practice for the benefit of humankind and the highest good of all.

As we experience time flying by, information is filtering into our consciousness from other realms. As our consciousness is raised, we open ourselves to receive more and more information. By daily use of the coloured rays in our lives, great discoveries await us. In ancient Chinese culture, it was accepted that the purpose of music was to maintain balance of the harmonics of heaven and earth. They rarely used the seven-note scale but rather divided the octave into 12 parts and provided the foundation notes for the 12-year cycles of the ancient Chinese calendar. The Chinese understood that certain music had both a positive and a negative effect. When our chakras are in alignment, we sing to the universe.

Our bodies are precise, wonderful instruments that we need to work with to keep in tune, harmony and balance. By consciously using colour with every healing method we choose, we can help ourselves rebalance and resonate on a higher vibration. This naturally opens and heightens our intuitive abilities so that all our senses are operating at their optimum capacity. For many, sound and music are some of the most enjoyable ways to do this. Sound has the capacity to change the chemicals within our body and outer environment. Through the use of particular sounds or sequence of sounds, we can achieve positive changes on every level of our being. Research has shown that certain sounds cause changes in our heartbeat, blood pressure, breathing, circulation and immune system, and depending on the choice of music, affects our moods. By playing and listening to inspirational harmonious music, we assist in raising and harmonising the vibrations in ourselves that have been deharmonised through negative thoughts, actions, feelings and circumstances. It helps to

bring us back into alignment and at the same time expands harmony out into the environment. Through the right choice of music we are able to raise the vibrations not just in ourselves but in our homes, therapy rooms and workplaces. When we have cleansed ourselves and our environments energetically, others feel uplifted by our presence and enjoy the space that we have created.

Sound has been used in many different cultures to change, clear and move vibrations. Temple bells are used to encourage us to focus. They help to attune our minds to spiritual matters. Mayan bells clear the auric field; drums and gongs attune us to the deep throb of red and the earth's energies. A sense of relaxation can be felt through listening to new age music, which is mostly in the key of F and links to green and the heart centre. We each have our own note and when we find it, we can reharmonise ourselves as the ancients did. Until that time, we can help ourselves by playing harmonious music. Chants and mantras sung or spoken regularly will also induce changes in our bodies and our environments.

The Age of Aquarius will be a golden violet age in which we will experience a quantum leap in consciousness. Colour, sound and aroma will be at the forefront of healing in the future and many 'new' exciting ways of using these will be rediscovered. Indeed, many are already working in the field of sound for healing and achieving positive and wonderful results. Working with sound treatment, healers have discovered that certain frequencies can help a vast array of imbalances and conditions, even breaking up kidney stones and gallstones so that they are easier to pass out of the body. Stiff joints become more mobile, psoriasis, ulcers and many other complaints are all helped by healing sound.

The work of great composers is now being used to bring in the angelic forces and move humankind forwards and upwards. Handel's *Hallelujah Chorus* is one such great piece. In class I ask my students to stand with their eyes closed to experience this joyful and inspiring music. It is tremendously uplifting and unifying to mind, body and spirit. Those who can see auras will confirm that it affects the aura in a very positive manner, rebalancing the chakras and cleansing and expanding the auric field of each individual in the room. As each aura expands and deepens in colour, they unify with the auric field of each individual in the room.

The Messiah is the most famous of Handel's creations. With its many arias and choruses it takes several hours to perform and yet Handel composed the entire work in just 24 days. During this time he was like a man possessed, hardly eating or sleeping. Handel himself said that while he was composing the work, the heavens seemed to open. Aura pictures of the vibrations of this music have shown a crown-like shape, with long shoots bursting from its centre with clouds of brilliant colours, the strongest being gold, red, blue and green. A heavenly piece that we can all benefit from playing either by ourselves or within a group.

Many artists have found that they have created their most powerful works whilst listening to a certain piece of music. The music releases their creativity and allows it to flow through them. Some require the music to be played as loud as possible to enable them to lose themselves in their work.

The more sensitive we become, the more in tune with our bodies we become. We immediately recognise a piece of music that uplifts us in the same way that every nerve ending in our bodies winces when we hear a disharmonious sound. When we combine sound with movement, we regenerate the life force and the meridians or energy pathways within the body. Sound and movement start up a process of harmonious vibrations and as we vibrate at a higher frequency, so our consciousness expands.

Musical keys, colours and chakras

Each musical key has its own colour and is linked to one of the chakra centres.

COLOUR	KEY	CHAKRA	ORDER
Violet	B	Crown	7th
Indigo	A	Third eye	6th
Sky blue	G	Throat	5th
Green	F	Heart	4th
Yellow	E	Solar plexus	3rd

| Orange | D | Sacral | 2nd |
| Red | C | Base | 1st |

Babies and children

Harmonious music is good for all of us. Music can be heard in the womb and can have beneficial effects on both baby and mother during pregnancy as well as helping to ease the birth and the after-effects of labour. A baby will learn to associate music with safety, comfort, true relaxation and peace if one piece is chosen and regularly played throughout pregnancy. If played after the birth it will still and calm the baby well into the toddler stage and beyond. The bonding between mother and child is gradual and not immediate, and a specifically chosen piece played throughout as well as at feeding time will help this process.

It would be wonderful if every child had the opportunity to play a musical instrument. It should be an essential part of every school curriculum as learning to play an instrument is known to benefit co-ordination, accelerate learning, encourage self-expression, build confidence and help establish regular sleep patterns, to name but a few.

Colour and music associations

Apart from the physical benefits, we are only beginning to realise the tremendous benefits of music to other levels of our being. Music played with colour awareness and from the heart touches our souls because that is the very place that it comes from. Here is a list to help you identify different colours in music.

| RED | Red music helps to re-establish contact with Mother Earth, to ground us and ensure that we remember our roots. It's strongly rhythmic – bass, drums. |
| ORANGE | Orange music is related to the element of water. It allows the emotions to flow and helps us to feel the joy of life. Cello, saxophone, some types of jazz, brass band music and trombone. |

YELLOW	Yellow music is related to fire. It harmonises and frees us and has no boundaries. It is rhythmic, orchestral and fiery.
GREEN	Green music is air music. It hits the heart, especially new age music and some classical. It awakens and stirs the feelings of love, peace and relaxation.
SKY BLUE	Sky blue music opens us to the ether element and allows us room to breathe and to be so that we can open to the voice of the gateway to heaven. Piano, guitar, viola, trumpet, some jazz, the blues and classical.
INDIGO	Indigo music is inspirational, leading to new insights and giving us clarity. It is linked to higher knowledge. Piano, organ, clarinet, guitar, violin, the blues and classical more dramatic types.
VIOLET	This is 'I am' music – not of the ego, but the universal all is one and interrelated. It awakens us to our wholeness and to the sound of the higher dimensions. Violin, harp, synthesiser, soft ethereal classical music and the more haunting pieces.

The OM chant

The OM chant is another way of harmonising the self as well as uniting a group. I find it is uplifting to let a group 'go' on the OM. The most beautiful sounds can be heard as participants warm to the sound of the OM, and enjoy the sound and feel of their own voice.

I ask students to begin in their own time, some starting first and the others following to create a glorious OM chorus. They usually hold hands and encircle each other, creating a spiral. As the leader reaches the middle, they come out again leading the group into a large circle. A few moments of silence is experienced when they have finished to feel the sensation of oneness and upliftment and to experience their bodies vibrating.

The OM is powerful to sing or hum in the evening. Before sleeping it ensures that your body will release the day's events, relax and rest. When you practise the OM, you can also hold your hands in the shape of a pyramid. This connects us with the three words – love, truth and wisdom – that, when spoken together, create a serene harmonic

balance within. If life's ups and downs are creating problems for you or you are feeling unsettled in any way, go for a walk and repeat these three words to yourself. You will find an inner calm and strength that was missing when you started.

The Lord's Prayer

In the Lord's Prayer we find specific lines that correspond to the specific colours of the seven chakras or centres. As we recite or sing the prayer, it opens the seven centres in a particular order. This knowledge was known but has been lost to the majority of us over time. Groups of people are now becoming aware of these techniques as the ancient truths are being rediscovered. A truth cannot be lost, but rather awaits to be rediscovered.

Our father which art in heaven	7th Chakra
Hallowed by thy name	6th Chakra
Thy kingdom come Thy will be done On Earth as it is in Heaven	5th Chakra
Give us this day our daily bread	1st Chakra
And forgive us our trespasses As we forgive those who trespass against us	3rd Chakra
And lead us not into temptation	2nd Chakra
But deliver us from evil	4th Chakra
For thine is the kingdom	Returns energy to throat centre – 5th Chakra
The power	Returns energy to the crown – 7th Chakra
And the glory. Forever and ever. Amen	Returns energy to the third eye centre – 6th Chakra

Movement, flexibility and suppleness

Movement, music and colour go hand in hand. A flexible, supple body allows energy to flow freely through it. The endocrine system is linked to each of the seven centres or chakras, and the energy flows from one centre to another, continually working to keep the body in balance. We know that we can upset this fine balance and that we can use colour to replenish and recharge our centres. The flow from one centre to another is also aided by our movement. Stagnating energy can be held in parts of our bodies, such as our knees, hips, ankles and toes if we choose not to become more supple. Elvis Presley knew that rotating the hips and pelvic area was a great way to get the energy moving through the body, not to mention everyone else's!

Getting energy moving

A rebounder (a special type of mini-trampoline) is a wonderful way to get the energy moving and obtain suppleness and flexibility. Or you can put on a piece of music that you enjoy and move around the room. Sometimes you might feel like flowing gracefully and at other times you might want to boogie. There's no right or wrong way, as long as you enjoy it and it feels fun. Music can even help jazz up household chores like dusting and vacuuming. As you move around the room, grasp the floor with your toes and then loosen and relax them again. Stretch your spine, legs, arms and neck. As you stretch out your arms, rotate your wrists, open and close your hands and when they are open, stretch out your fingers as far as they will go. Then take each leg and do the same, stretching out your toes and turning your lower leg so that your ankles are rotated comfortably.

Don't forget to exercise your voice as well as your body. Sing as you move or hum – even whistle, but do make a sound or sounds as you move. At some time during the exercise, flop forward gently and allow your back and spine to relax. Then when you feel ready, stretch up again on tiptoes and try to reach as far up as you possibly can. You can use a coloured silk scarf as you flow around the room as this will aid your gracefulness and also act as a mild focus of colour, giving your body a subliminal message as you move to the colours of the music. As you stretch and move your body, hold the specific colour of your choice in your hand, as this will be the centre that

needs the most attention. As you are moving around, the colour will redress any imbalances.

This can be a fun exercise to do with a large group as everyone moves, sings, claps, jumps, skips and laughs at their antics. The less self-conscious you are, the more fun you have. Inhibitions soon disappear when people lose themselves in the music. At some point, close your eyes and 'see' what colours or coloured symbols are coming to you and experience how your body feels. As you stand still, observe and listen, you may experience a rush of energy pulsing through your body or a tingling sensation in one or two parts.

The five-pointed star

The five-pointed star exercise is a full stretch exercise. Stand comfortably with your legs a little apart, then pull your spine up as far as you can stretch and stand as tall as you're able whilst keeping your feet on the floor. Then stretch your arms, including your fingers, up and out away from the body. Stay like this for a little while, then, when you are ready, flop forward gently and relax the top half of your body. Become totally floppy as you fold in half, allowing your arms to dangle in front of you to the floor. Repeat this five times, and then move freely around the room, clapping your hands and stamping your feet. This releases an electrical charge up your spine that is very beneficial for moving the energy through your body. It also helps the circulation and is reportedly good for premenstrual syndrome. When we stamp it activates the red centre and re-energises our bodies. When we sing, our energies flow freely and we are lifting the vibrations in ourselves and our surroundings.

11

Colour and Art

Art therapy

Colour is often used therapeutically through art. We all know the experience of our senses being heightened when we look at a piece of art that we love. It evokes a deep sense of wellbeing in us, inspires us and fires our imagination. You don't need to be an artist to work with colour therapeutically. Your only guideline is to link in and express yourself with colour on to paper. Jung believed in the symbolic power of colour and he actively encouraged his patients to paint spontaneously to help them express what was deep in their unconscious. We can express our joys and disappointments and release our emotions and fears through colouring. Our deepest and innermost thoughts that we dare not share with others can often be released through the medium of art, just like writing a letter to ourselves that is for our eyes only releases our pent-up emotions. It is far healthier to release these repressed feelings than to allow them to fester, often emerging as an inappropriate outburst or going deeper and manifesting as a physical ailment.

You may find working with colour in this way more beneficial than writing yourself a letter as the vibrations of the colours you use will assist in healing you as you work. Use whatever medium you feel comfortable with – coloured pencils, crayons, pastels or paints.

Children often find it easier to express with colour and can say so much more through images on paper than they do in words. Trained art therapists working with children can see in their work what they're not able to express verbally. It is an excellent way of working with children who have been abused, are emotionally disturbed or suffer from some other kind of disorder.

Disturbed or emotionally distraught people often choose brown or black to work with on their first picture, but gradually introduce more colour as they do more work.

Creating with colour

You don't have to be trained to gain enjoyment and insight. Put on your favourite piece of music and lose yourself in the music and colour with no thought of what you are about to create or why. Clear your mind and focus on the music and the colours that you have spread out in front of you. Go beyond your inhibitions and preconceived ideas and enjoy creating and losing yourself in colour. Don't try to create any form as such but rather allow your hands and wrists to flow freely and easily as they move across the paper. When you have finished, stand back and look at what you've created. What were the main colours that you used? When you began with no thought of creating forms, what forms did you create? And what colours were these? Then refer to the list of colour meanings (see pages 10–19) to give you some insight.

Gaining insight

It's possible to gain insight into many issues with the above method. In a colour group, I will first decide what the students will be creating. It may be a combination of symbols, animals, nature, a family situation or some of these combined. Before starting and linking in with the light, I am focused and centred and hold the awareness of the meaning of the symbols that I will be giving the students to create. They themselves

are not aware of the meaning and won't be until they've finished. The students are then asked to link in with the light and ask that whatever they're given is for their highest good and purpose. Soft music is played and I request that this exercise be carried out in silence. Once each student feels that they are centred and attuned, they begin creating in colour, in whatever way they choose, a picture that contains the symbols I have given them. When everyone has finished, the students form groups and create a circle with their chairs. (Never forget the power of the circle in light work. Energy flows and circulates freely in the circle shape.) The meanings of the symbols are then revealed to them. These act like tuning forks and provide a way in. The students are then asked to give each other insights into their pictures, spending approximately 15 minutes on each. It is truly amazing what is revealed in these sessions and they are hugely enjoyable.

These sessions aren't carried out until half way through the course, by which time the students have attained enough knowledge to put into practice for themselves. To give an example, when a bird is used as a symbol of the self, what colour is it? How large is it in comparison to the rest of the picture? Is it free and flying? What type of bird is it? Consideration must be given to the whole picture and content, working first from the colour viewpoint and then considering the whole picture, i.e. how has the content been placed and what is it doing? The group is guided by their intuition and encouraged to express how they feel and what comes up as they hold and look at each other's pictures. As they tune into each other and hold the picture, they are holding and linking into the other person's energy. Students are always surprised and delighted by the insights that are given to them.

Take a look around you – do you notice the colours of the different murals and pictures in your environment? Many artists who have an understanding of the deeper effects of colour are bringing their artwork into the workplace, shopping malls and hospitals. For surgical areas, natural scenes are used with a majority of greens and blues to calm and ease the nervousness of the patients. More earth red colours are chosen for areas that people pass through but don't stay in. In an area where the queues are likely to be longer than usual, and to keep frustration and impatience to a minimum, specific calming colours and shapes are chosen.

Mandalas

Loving is not looking at one another but both looking in the same direction.

<div align="right">ANTOINE E SAINT EXUPÉRY</div>

The word mandala is from the ancient Sanskrit meaning circle or central point. A mandala is a circular pattern that can represent our inner world or the universe. Some can have intricate patterns. Others are simpler in nature.

Creating your own mandala

You can create your own mandala by first drawing a circle roughly 6in (15cm) in diameter, then two smaller circles in the middle of the larger circle, one within the other, approximately 3in (7.5cm) and 1in (2.5cm) in diameter. Your mandala is now ready to colour in. Experiment with as many colours as you wish, using circular movements to colour it in. It's easy to lose yourself in the circular shape, the circular movement and the colours. Work in silence with soft music playing.

The outer edge of the largest circle represents the ease with which you are able to step into the unknown. Change is scary for a lot of us. We can object to certain areas of our lives, but are unwilling to make changes. We stay in the comfort zone of the known. By staying within the line you can be fearful of change, by colouring outside of the outer line, you are ready and willing to step out and to make the necessary changes. Ask the questions and make the decisions that will instigate change. The 'skin' of the mandala can be seen as the outer protection and it also protects and nurtures what is inside the circle. The colours used inside the larger circle will give you clues as to which area is affected. Physical? Or spiritual? The physical colours are the magnetic colours: red, orange and yellow. The spiritual colours are the electrical colours: sky blue, indigo and violet. Green, wherever it is placed on the mandala, represents balance and harmony. The fresh lime and apple greens indicate new growth and new beginnings, even a fresh outlook. The space inside the second circle represents the present state of your consciousness. The smallest circle represents your own centre, the

innermost essence of your being. When interpreting a completed mandala, notice the depth of the colours used, and the shapes that have been created. Initially relay what you see with your eyes, then focus into the centre of the mandala, and relay what you feel. Once you are comfortable working with mandalas, you will find information coming through that is accurate, potent and compelling. Look for the balance in the overall picture. Some can be either top-heavy or lop-sided. Looking at the mandala, draw an imaginary vertical line down the centre. The left side of the line represents the left brain, our analytical, logical and reasoning side. The right side of the line represents the right brain, our side of imagination, creativity and intuition. With patience and practice you will source wonderful insights from this medium.

The globe exercise

This exercise is one that may need to be carried out and then put to one side for future reference. A trip across the world is not always possible the moment you have created your globe! Everything is in perfect order and has its right time; whatever part of the globe comes up for you through this exercise will hold some importance, whether that be now or in the future – finances permitting! This is not an exercise depicting the past, it is very much an exercise 'from this moment in time'.

Draw a circle, approximately 6–7in (15–17.5cm) in diameter on a piece of plain white A4-sized paper. Colour in the area around the outside of the circle with a blue that represents the colour of the sea for you. Fill all the space on the outside of the circle and colour out to the four corners of the paper. Now you are left with a white circle and a blue background. Go into a relaxed state, link in and see the circle in your mind's eye and imagine an orange dot. Think about where you would like to place the dot in the circle and when you are happy about where you want to place the dot, draw it into your circle with an orange pencil. Once your orange dot is in place, divide your circle up into 12 equal pie-shaped sections with a pencil.

The circle represents the globe and where you put your dot is an area of the world that holds some personal significance for you. By dividing the circle into segments it is easier to locate the place that represents your dot on the world map. Look up on a world map where your dot is and, hopefully, you will one day travel there, to begin another adventure ...

12

Colour and Numbers

The karmagraph

The rise of science established in our minds that all knowledge had to be proven, evident and seen to be true. A lot of spiritual knowledge seemingly disappeared because of this, but truths cannot be hidden and there are many inexplicable things occurring in our world that science cannot explain and can no longer ignore. We are now seeing many rediscoveries of the ancient knowledge coming through natural phenomena and many individuals worldwide.

Unfortunately there is also a lot of dubious 'knowledge'. The only way to differentiate is to follow and be guided by your heart. Trust that if something feels right for you, then it is. Work closely with the light of the divine worlds and you will always be guided, protected and navigated in light.

One aspect of the ancient knowledge that we are rediscovering is the method of using colour with numbers to give insight, show us our potential, reveal our inner selves and help us understand the deeper reasons for misunderstandings and difficulties in key relationships. It

can also help get us on to our true path. One way of using colour and numbers for insight and divining is known as the karmagraph.

Drawing up and interpreting your karmagraph

The karmagraph is a circle of colours and numbers. First draw a circle and place the numbers one to nine evenly around the outside of the circle in a clockwise fashion. Position number one slightly to the right at the top of the circle at approximately seven minutes past the hour. The other numbers follow and are equally spaced until you come to number nine at the top of the circle. Each number from one to nine has its own colour. Colours one to seven are the colours of the rainbow, starting with red, eight is magenta and nine is gold.

Red	1
Orange	2
Yellow	3
Green	4
Sky blue	5
Indigo	6
Violet	7
Magenta	8
Gold	9

To find the numbers you need to place on your karmagraph, you need to take your birth date, and reduce it down to three single numbers.

For example:
13 September 1967
Take the day of birth first: 13=1+3=**4**
Then the month: **9**
Finally the year of birth: 1967=1+9+6+7=23, 2+3=**5**

In this example you would then place the numbers 4, 9 and 5 around the edge of the circle. Starting with number 4, you would draw a straight line

from 4 to 9 and from 9 to 5. If you are doing a chart for more than one person, select different coloured pens for each individual before you start so that you can see where they meet and cross clearly on the chart. It is especially important to do this for three or more or you will lose where each person is on the chart. You can also use a fourth number/colour and to obtain the fourth number you need to add together the three numbers gained from the birth-date. In this case it will be 4+9+5=18, 1+8=**9**

Once you have confidently secured and placed the first three numbers around the circle, link them together in their order of day, month and year. Join them together with a straight line drawn from first to second to third number. Then add the fourth number. Connect the third and fourth number on the chart with a broken line.

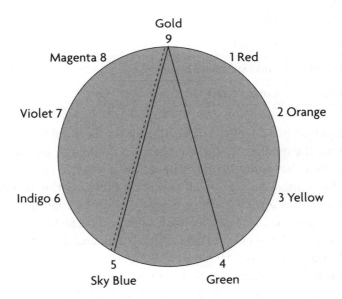

Sample karmagraph (Birth date 13 September 1967)

The first number shows you what tools and qualities are at your disposal and what attributes you have come in to this life with. Are you fully utilising your gifts? The second number shows what attributes you need to be working with in this lifetime. When you work with them it will make your journey an easier road to travel. The third number shows where you are going and what is possible if you harness the colour attributes available to you. The fourth number

shows you your mission and life's purpose. Your path will be smoother if you connect to and work with the qualities of your fourth number. It can also highlight your weaknesses.

The following will give you further clues into the levels of insight that these colours and numbers can offer.

1	Red	Physical
2	Orange	Emotional
3	Yellow	Mental
4	Green	Balance
5	Sky blue	Soul purpose
6	Indigo	Wisdom
7	Violet	Sensitivity
8	Magenta	Links spirit and matter
9	Gold	Completion of higher service

If you find that two or maybe three of your numbers are the same, this shows that the qualities of these colours and numbers are magnified. You will find that some karmagraphs show a triangle once you have joined the numbers up. Look at how wide this is as this shows how expansive the person is. If you find two sides of the triangle, look and see what number you need to work with to complete the triangle. Qualities from all the colours in your birth date and the extra number needed to complete your triangle can be given.

When using the karmagraph as a means of divining for yourself or others, please remember the golden rule of tuning into the qualities of the colours first and foremost. Refer to the interpretations for the colour cards (see pages 10–19) as well as the following interpretations.

RED

You need to allocate tasks. You are an all or nothing person. A pioneer, ground breaker, leader, you're rebellious, independent, determined, courageous, headstrong and ambitious.

A dynamic powerhouse, you're passionate about life. You enjoy

change and movement and can be restless or easily bored. You're active in both the home and the environment. However, you can quickly become tired and burnt out and need to rest more. You also need to overcome negative thought patterns and release that guilt. And remember, red, to lead is not telling others what to do. *Reds start things, are independent and work on their own initiative.*

ORANGE

Key words for orange include expressive, joyful, humorous, vital, creative, adaptable, sociable, confident, spontaneous, self-respecting, active.

Look at what you eat, orange. Don't eat on the run. Try a new exercise class – what about tap dancing? Line dancing? Let your hair down and have some fun. Use your creativity and overcome your feelings of inadequacy of expression. Your inner wisdom needs expressing. Are you a hypochondriac or a health fanatic?

Oranges join in, are adaptable, bubbly and creative.

YELLOW

You need to expand your awareness of your inner self and think carefully before acting. Do you need to bring the sparkle back into your life, yellow? You make an impact socially, people always remember you. Try to stop analysing and get into feeling. You have a good mind, but please remember you are not always right! A born collector, you have an eye for a bargain. Key concepts for yellow include ideas, clarity, intellect, self-absorption, creative wisdom, right judgement, personal power, self-esteem, discernment, confidence.

Yellows oversee and like to take control.

GREEN

An open house can be wonderful, but not when all you really need is peace and your own space. Learn to identify and meet your own needs. Your lesson is unconditional love; others you meet on your journey will mirror back this lesson to you. Love is the greatest healer so listen to the voice of your heart, green. Concerned about being alone? No, you won't tire of your own company, but you'll never be alone for long – where else will your friends go for good, sound advice? Crucial to

greens are relationships, self-love, groups, balance, earthing energy, self-discipline, practicality, generosity, humility, harmony, compassion, concern for the planet, kindness, equilibrium, nature.
Greens provide stability and practical common sense.

SKY BLUE

Are you nourishing the part of you that needs to be doing something worthwhile in the community? Never presume that others know what you know to be true. You have a deep, true knowing. There is a possibility that something needs to be talked through. If you sense and feel that something isn't right, let your instincts guide you. Think before you speak, blue; once said, hardest mended. Key concepts for blue include communication, diversity, expression, intuition, awareness, healing, soul's purpose, mastery of thought, trust, faith, truth, serenity, faithfulness, gentleness.
Sky blues communicate and seek a higher motive.

INDIGO

Teachers, therapists and idealists are likely to be indigo people. Your highly attuned intuitive awareness has been earned – 'spiritual truths are earned, never learned'. Go on continually developing and opening to the higher realms, indigo. Practical solutions to a current dilemma can be found. You love meeting people but sometimes need a rocket to get you out of your comfort zone. Down-to-earth with a sense of humour, use your practical skills and be active in your local community. Important to indigos are higher knowledge, power, understanding, responsibility, intuition, attunement to the higher mind, brotherly love, loyalty, integrity, high ideas, vision, acceptance, unity, devotion.
Indigos provide wisdom, the basis for real power.

VIOLET

There's serious inner work taking place that you must share. Slow down, assess what you want from life. You have the ability to assist many. You are gifted and open to success – why doubt it? You will become listless and down if you do not accept and appreciate your very sensitive nature. Seek work in either the humanitarian or environmental area. Key words here are sensitivity, insight, inspiration, high ideals, truth,

inner knowing, reverence, kindness, justice, spirituality, healing.
Violets provide sensitivity, linking to higher dimensions.

MAGENTA

What needs to be organised in your life at this moment? Release and
let go of what is holding you back. Go in and recall and rediscover
past knowledge. It will be a natural process for you. You understand
the lesson of gratitude with your high degree of maturity and
understanding. You are protective, compassionate and very gentle. Go
with the flow, magenta. Important to magentas are business acumen,
ambition, unity with higher consciousness, organisation, knowledge,
balancing of spiritual and material, bringing the spiritual into the
business world, respect, divine love.
*Magentas unify self, i.e. mind, body and spirit, and effortlessly link
to a higher consciousness.*

GOLD

Gold signifies completion. You are at one with yourself and your
surroundings. There is total acceptance of the physical and spiritual
connection – all is one. Joyful experiences await you, gold, they are
just over the horizon. Can you see them rising before your eyes? No?
Well, it won't be long before you are dancing with delight; enjoyment
and deep joy is yours for the taking. Life is about to become a glorious
bowl of cherries, take your pick. Important to golds are unconditional
service for the highest good of all, benevolence, spiritual power, mercy,
sacrifice, completion, fulfilment, wisdom.
Gold is completion.

Using the karmagraph for relationships and key events

You may use the karmagraph to see where you and your partner, family and
friends link. If you do not link to the same colour/number with another or
the lines cross over each other, this can show you may be together for a
time in a relationship or marriage but that you may eventually part. If you
do decide to stay together, you will lead very separate lives, follow separate
paths, that you may have different circles of friends but stay under the same
roof. For some this is not easy but not impossible. For others and within

friendship this can work very well, both bringing very different input and enriching experiences to the union.

Once you have drawn your karmagraph and placed the numbers on to the chart, observe the colours you both have and see where you have helped each other view life from another perspective. What are you learning and giving each other? What have you been able to teach each other? I have always been amazed by the information that has come through for another when using this method. By linking into the colour vibrations of each number, the karmagraph will give you the clues as to what you've come back to learn and what colours will help you achieve your mission. It is a powerful tool and can be used to help us not just in relationships but in many areas of our lives. Try drawing a graph with the date of an important event, then put yourself on to the chart. Again it will give you some invaluable insights. You can also use the technique to set dates for future events that will augur well with your chart.

The mystery of numbers

All great discoveries are made by those whose feelings run ahead of their thinking.

ALBERT EINSTEIN

The two numbers that hold mysteries to be rediscovered are four and seven. We have seven major planets, seven wonders of the world, seven musical keys, seven colours of the spectrum and seven main chakra centres. Four multiplied by seven equals twenty-eight, the cycle of the moon and the female cycle. With four we have the four corners of the earth; the poet Goethe stated that four colours make all, four archangels represent the seasons on earth: Raphael – spring; Uriel – summer; Michael – autumn; and Gabriel – winter. When the four levels of our being are in balance, physical, mental, emotional and spiritual, we are in harmony with each other, we are whole. The sun passes through four cardinal points, two solstices and two equinoxes. In ancient Greece, four bodily fluids were used as a form of diagnosis. Ayurvedic medicine is based on four principles as are other ancient healing methods. The Greek philosopher Aristotle maintained that all colours derive from one of the four elements – air, water, fire and

earth. Other great thinkers agree that there are four personality types corresponding to the four elements.

Magenta is a combination of infra-red and ultraviolet and can be seen through a complex arrangement of four prisms. Two multiplied by four equals eight and, in esoteric numerology, number eight is the number for earthly and heavenly balance – as above so below. The figure 8 contains two circles and eight in numerology corresponds to the eighth colour – magenta.

Two is also a number that holds secrets; it is the only number to be depicted in the tarot pack. Two can either be the number of universality or division. In the tarot pack the priestess is seated on two pillars. In her left hand are two keys and in her right hand a book. Do these symbolise our need to study the two in order to obtain the keys that will unlock the golden wisdom? As mentioned, two can be the number of unity and expansion or the number of separation and division. Interestingly, orange, the colour of number two, is the one colour that receives the strongest reaction from people. They either love it or can't bear it. There appears to be no middle ground with orange.

If we take four and add it to seven we get eleven. Bringing this down to single digits, we arrive at two (1+1=2). Four and seven hold within them the same lessons as the number two. Fours can become stuck by holding tightly on to their opinions, not willing to see the wider picture from others' perspectives, and by refusing to consider others' views. Sevens can be opinionated, stubborn and feel superior. Both four and seven have the opportunity to eliminate these negative aspects of themselves if they work with the qualities of the two, of orange – the great liberator.

13

Colour in Our Environment

The circle

The power of the world always works in circles,
And everything tries to be round.
The sky is round, and I have heard that the earth is like a
ball,
And so are all the stars.
The wind in its greatest power, whirls,
Birds make their nests in circles.
For theirs is the same religion as ours.
The sun and moon, both round, come forth and go round
in a circle.
Even the seasons form a great circle in their changing.
And always come back again to wherever they were.
The life of a person is a circle from childhood to childhood,
And so it is in everything where power moves.

BLACK ELK

The circle is the perfect, stressless shape. From the atom and cell to the earth, moon, sun and planets, all life moves in circles or cycles. As humans, we live, breathe and have our being in the circle; the circular motions of the earth, the power of the circle, always returns to its starting point. All that we send out, whether in deed, thought or action will return. 'What goes around comes around.' There are no coincidences in life. The law of the circle is exact and our greatest achievement and task in our everyday life is to ensure that all of our words, thoughts and actions agree with our intent.

The Native Americans are just one of the many cultures that work within and from the sacred circle principle. Within circular sweat lodges people talk, share, confess and heal while sweating and purifying both the physical and spiritual bodies. The atmosphere is purified with one or a combination of sage, cedar, pepperwood, sweetgrass and Douglas fir for protection. (Douglas fir and white spruce are two of my favourite essential oils. They are not readily available but do try them for yourselves if you can source a supplier.) Herbal drinks are taken to purify the body and there are songs and chants to aid the release. When participants come out of the sweat lodge, they wash to cleanse and refresh themselves, leaving behind in the sweat lodge any negativity. This is absorbed into the power of the circle where it is diffused. The fires they light represent the sacred light.

The collective energy of groups is very powerful and is even more so if the circle principle is followed and the energy can flow uninterrupted. If you are carrying out group or partnered work in a circle, ensure that the inside of the sacred circle is clear of any bags or pens and ask that these be put outside. As a group stands or sits in a circle, sometimes holding hands and sometimes not, I always open the session by asking that we salute the divinity in each other and pour out unconditional love to each other. Then I ask each group member to non-verbally send love out to the person on their left. After a few moments, I ask them to imagine a golden thread linking us all at the waists. Our circle is then surrounded in love and golden light as we are joined in love and light.

In some groups the practice is to request that everyone introduces themselves to the rest of the group and says a little about themselves. This is supposed to be an ice-breaker. I have found that this can make some people cringe with embarrassment or shyness, which dissipates

the energy that was starting to build up in the room. So, to lift and unify, I get the groups to sing together and then we begin the course on a 'higher note'.

You can envisage yourself in your mind's eye encircled in light for your protection and illumination at any time. When you feel in need of divine guidance, encircle yourself in light and link to the divine and ask that you be guided and shown clearly the way. End with thanks and be patient as your answer or solution may come in a dream or symbol, from a friend or from something you read. Stay aware and watch for the cue cards and, above all, have the courage to act on them.

Colour circle exercise
• • • • • • • • • • • •
One of the many colour circle practical exercises that you can carry out within a group is to draw and colour in three circles, in three separate colours, on a sheet of white unlined paper. When everyone has finished, get into small circular groups with your pictures. Mark your circles in the order that you drew them. Deciding who goes first, one by one the group 'reads' each picture. The first circle drawn represents the past, the second the here and now, and the third your future direction, where you are going.

Fashion, clothes and corporate colours

Fashions change, but over time we see this is an area of our lives that also follows the great law of the circle and goes in cycles. We bring ideas back from another era, with just a few changes to modernise the look. The colours used are a visual reflection of our group consciousness at the time and it's refreshing to see fashion becoming more colourful.

Ideally, we should all be choosing the colours that we like and express who we are rather than slavishly following fashion trends. The colours that we wear are affecting us constantly as we absorb them through our skin. We are all affected by the colour vibrations of our clothes and those of others, particularly if we are wearing natural fibres, especially silk. Look at your colour preferences in clothes. When you go through a colour change do you ask yourself why? On pages 134–135 is a list of some of the qualities we experience

and convey when wearing certain colours. A more personalised and detailed consultation with a colour therapist will give you a much fuller and in-depth analysis.

In the business world, the corporate colours chosen are of utmost importance. What messages are your corporate colours sending out via office décor, uniforms, corporate logos and even stationery? To portray your business in the most harmonious light, the entire business needs to be looked at holistically. It will then emanate the right messages on every level. The staff will be more productive as they harmonise with the décor and each other and feel a strong sense of being part of the whole. This encourages company loyalty and increases productivity, making the business more profitable. A happy, efficient workforce striving to do their very best and interacting harmoniously and constructively will increase output and attract more customers. An initial consultation and a detailed report from a colour therapist will cover every area of a business. The colour therapist will then organise and oversee the changes that have been recommended and agreed.

Interpreting clothing colours

Black is a colour that has been used extensively in the fashion world and no doubt the 'little black dress' will continue to hold its place within every woman's heart and wardrobe. Black can be sexy, mysterious and dynamic and is worn a lot in the business world to portray a determination to get the job done.

In nature, each seed that is planted germinates in the dark before it gathers momentum and, with great strength, pushes up and out into the light. Black is inner strength and holds the potential of what can be. It is the colour of discovering one's own individuality. It also gives strength and power to the following colours when worn with them:

With red	physical power, stamina and leadership
With orange	social power and confidence
With yellow	mental clarity, intellectual power, persuasive reasoning
With green	harmony and adaptability

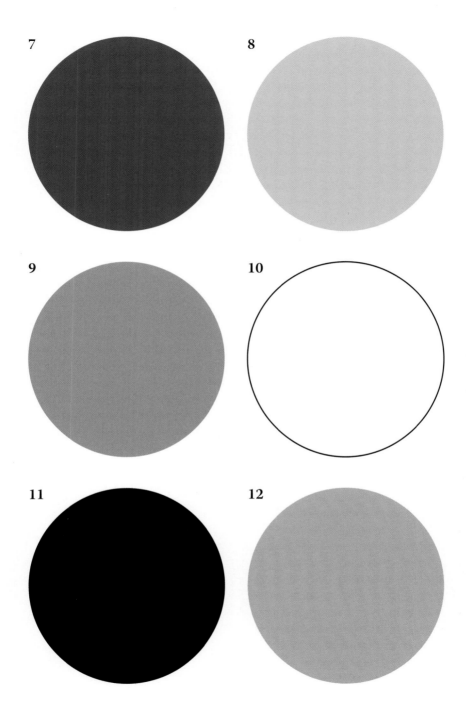

With sky blue	trustworthiness and sincerity
With indigo	knowledge and correctness
With violet	Inspirational integrity

White, the colour of purity, reflects all colours and mirrors back what we are. We need to be well and glowing to wear white or it can drain us. White is the colour of the broadminded person who can see all sides of a situation. It's cool, joyful and always striving for perfection.

Brown is the colour of earth and represents security, solidarity and permanence. It is the colour of the materialist.

Red gives us energy, gets us moving and arouses our passions. We feel warmer in red than in any other colour. We feel courageous and determined. Red encourages us to come out of ourselves and be more outgoing.

We feel confident in **orange**, sociable, extroverted and constructive. We feel youthful, fun-loving and adventurous in orange. It's an energetic and warming colour and stimulates us to be more creative and independent.

Yellow is warm and expansive. We are open to new ideas, clear and alert. It's the coolest of the warm end of the spectrum. It lifts our spirits and generates happiness, confidence and positivity.

Green is open, calm, adaptable, relaxed, friendly and harmonious. It's the colour of the diplomat and lovers of nature and equilibrium. Apple green is fresh and youthful. It denotes vitality and new ways of doing things.

Sky blue is a 'trust me' colour. It's cool to wear depending on the shade. It indicates sincerity, loyalty and keeps you coolheaded in stressful situations. It also calms your nervous system.

Indigo reflects understanding, knowledge, order and confidence. It's a colour of tranquillity and reasoned thinking. It too calms the nerves.

Violet depicts purpose, focus, integrity and dedication. It generates feelings of self-worth and boosts self-respect.

Pink is soothing and relaxing. It shows confidence in one's femininity and abilities.

Colour and décor

We have already seen how the colours we choose to surround ourselves with in decoration have an effect on our mood and wellbeing. We can either create an oasis of calm or a stimulating environment for play, study and creative pursuits with the colours we use to decorate our homes. Colours can assist children to learn, help take the artist and musician into a state of creative flow, give the elderly the will to live and be more active, calm disturbed teenagers, help insomniacs to sleep, and boost our immune systems to shorten the length of our convalescence. Our homes are our sanctuaries, our territories and the hub of our lives. They are where we can be ourselves and return to for comfort, relaxation and protection from the outside world. It's no wonder how important it is to create a healing, peaceful and uplifting environment for ourselves and our families.

Homes have energy vibrations that have been built up by their occupants and their contents, including the décor. We have all experienced the atmosphere of different buildings, some we feel immediately at home in, they feel warm and welcoming. At the other extreme, in some homes we are loath to cross the threshold. Yet from the outside they may be identical buildings. The colour scheme we choose for our home is one of the most important areas from which to build a positive, harmonious atmosphere. Because our homes are so personal, we need to 'feel' at home by using our soul colours.

Choosing colours for your home

You can choose from one of the many paint manufacturers' colour charts, or from another source that contains a full range of colours. Make sure that the colours you pick from contain as full a range of colours as possible, including the seven spectrum solid colours. Before you choose, lay the colours out before you and sit quietly for a few moments. Settle in a relaxed way, close your eyes and focus on your breath. When both body and mind are quiet, open your eyes and scan the colours quickly for a moment. Choose the colour that stands out from all of the rest, the colour that you most love. (In colour therapy, we call this your soul colour.) Do this quickly before logic and reason step in.

Repeat the exercise but this time choosing a colour that instantly gives you a sense of comfort and relaxation, and lastly scan for a colour that awakens and inspires you. You may find that more than one colour leaps out at you; this is fine. Whatever you choose, there are no mistakes.

You now have a choice of colours that you have chosen by intuition and feeling rather than logic. These colours can either be used as they are, or in a lighter shade. You may choose from within the full range that these colour choices offer, e.g. orange ranges from the palest peach through to apricot and burnt orange. You can now choose whether these colours are to be used on the walls or picked up in the soft furnishings. Let your partner carry out this exercise too and compare the colours that you have both chosen. You may find that you have chosen almost the same colours. If not, a compromise can be reached by picking up the colours in soft furnishings or by choosing from the complementing range listed under each colour below. Paint children's rooms in their soul colour and if it happens to be inappropriate for the wall, again you can use it for the paintwork and soft furnishings.

A guide to using colour in your home

Each person reacts differently to colour. Our choice of colour can completely change how we feel. Red can be passionate and cosy to one person, and feel irritating and restrictive to another. Similarly, blue can feel calming and peaceful or cold and aloof. All these feelings can be intensified by bringing in a darker shade of the colour or lessened by bringing in a lighter shade of the colour.

The following are only guidelines for the seven colours, remembering that there are many shades within each colour, and therefore many meanings. Always take your inspiration from nature. If you get a 'block' a walk outside amongst flowers in a garden or park will provide all the inspiration that you need for colour combinations.

RED
Red can arouse passions and arrest attention. It has been the choice of the brothel and the casino. It excites and arouses our emotional responses and stimulates our appetite. It can also aggravate and prevent us from relaxing. It is the choice of fast food restaurants; it gets us in

and moving along, creating a quick turnover. Red can give a sense of airlessness and bring the room in. It is therefore effective if a feeling of space or spaciousness is not required. Used in an inappropriate space it can give us the feeling of being stifled and claustrophobic and yet in certain shades it can give a strong sense of intimacy, cosiness and warmth. If you place a red item with another identical but different coloured one next to it, the red one will appear to be closer to you.

There are wonderful ranges of colours available within each colour band – many colours, many meanings. The red range includes the rich, earthy tones and terracotta that can be complemented with green, blue, golden yellow, lavender, aqua and gold.

ORANGE

Orange is a warming energy. From the palest tints of peach through to apricot to burnt orange, it awakens our creative potential. It is the colour for sociable activity, for extroverted fun and humour and constructive activities. Orange amplifies feelings of self-confidence and amiability. It stimulates conversation, love of life and youthful creativity. The orange range will liberate and help us to let go of inhibitions. Orange can be complemented with jade, blue, green, indigo, lime, aqua, some yellows and terracotta.

YELLOW

This is the colour of mental energy and can also be the colour of control. Yellow makes us think about how we are seen by others. It's not wise to use true yellow as a main colour for bedrooms, especially for children, as it activates the mind and the intellect. We find it difficult to switch off and relax if there's too much yellow. An excellent colour for study areas is sunny yellow – a yellow bulb used in the desk lamp or typing or writing on to yellow paper will keep you alert and focused on the job at hand. The coolest of the warm colours, yellow brings feelings of spontaneous enjoyment of action, uninhibited expansiveness, helps us to retain information, wakes us up, and is a cheerful colour of self-assertion and confidence. Boundaries, however, are more difficult to define in yellow and things can get lost. We can sometimes lose our identity and focus with too much yellow. It can be complemented with green, blue, violet, lilac, lavender and terracotta reds.

GREEN

The main colour of nature. The regulator, harmoniser and balancer. Dependent on shade, green can be the colour of tranquillity and relaxation. From the fresh energy of limes to the deepest green of ferns, it arouses feelings of brotherhood, unity and openness. It generates a calm space that feels serene, abundant, adaptable.

Green can create feelings of new growth and is complemented with rosy pink, gold, golden yellow, peach, apricot, blues, aqua, jade, red, magenta and orange.

SKY BLUE

Sky blue is the liveliest of the blues. The blue range of colours is the most popular and can be stunning when used with orange, far more striking in fact than when used with yellow. Sky blue evokes images easily and effortlessly of the sky and sea. People of all ages respond positively to sky blue. It is the trust-me colour, allowing us to focus on the task in hand, bringing us peace and serenity, giving us confidence to communicate. Sky blue sends messages of sincerity, truth and loyalty. It is known as the healing colour and it can be complemented with gold, terracotta, red, silver, coral, apricot, peach and pink.

INDIGO

Indigo is traditionally associated with sedation and rest, although some people find that they can study more effectively in indigo than any other colour as it can open the mind to inspiration. The colour of the higher mind and knowledge, indigo has a powerful energy that aids us in producing inspired ideas as well as releasing fears and blocks. Indigo allows us entry into the wisdom of the unconscious mind to find our own truth. The colour of the night sky, indigo can touch most emotions and thoughts with understanding. It can be complemented with apricot, coral, deep pink, gold, peach silver and terracotta.

VIOLET

Violet is the fastest and coolest energy and is linked to our highest ideals. It is the energy of purpose, focus and dedication. Like indigo it is the colour of dignity and divine creativity. It purifies and cleanses any atmosphere. The air will smell fresher, cooler and clearer in a violet environment and it raises our level of awareness to a higher

frequency. Violet helps us to be innovative. It can be complemented with green, yellow, pink, red, gold, silver, terracotta, pale apricot and peach.

Helping your family with colour

The colours you surround yourself with will affect you deeply. You can use your colour knowledge in many ways to benefit yourself and your loved ones. As you can see from the examples above, the colour arena is vast. Colours either side of each other in the spectrum will share some of the same qualities and you can create lighter or more intense effects by changing the shade of one particular colour. When you feel the need to absorb the qualities of a colour, place an item in that colour in the room where you spend a lot of time, so that your gaze catches it easily and effortlessly. With a little imagination, and without much effort, we can help our families and ourselves to experience the benefits of colour. If you feel members of your family need a change of colour energy, you don't need to redecorate. If children are going through a time of stress or intense study, are upset, having nightmares or need extra confidence, you can place something, perhaps one of their favourite toys, in a block of the colour needed on their desk or bedside table. This will help bring the chosen colour vibration into their immediate awareness. Cover a favourite current book in the appropriate colour, a pencil case they use daily, anything that will be looked at and may even be held.

For the younger child, encourage them to play with coloured paper. Cutting out shapes from coloured paper then sticking them on to blank white paper is a fun way of doing this. These coloured sticky sheets can be purchased from any art shop. Hang a poster containing all the colours of the spectrum in a place that your child can't help but notice, or scatter seven cushions in the spectrum colours on their bed or around the room. Place a favourite photo, in a coloured photo frame, beside their bed or on their desk. Use your imagination and refer to the colour lists above and in the back of the book to gain more insight into the different qualities of each colour. If children are having nightmares, getting them to look into the centre of an indigo or sky

blue circle for two minutes, then into the centre of an orange or pink circle for two minutes and then back to the indigo or sky blue circle for another two minutes will help to bring out and release their fears. Let the child choose the colours. Take out sky blue and indigo cards and ask them which colour they prefer. Do the same with orange and pink and use their colour choice for the exercise.

A special note on babies

Our babies today are wearing less and less white. The trend has been to use every colour but white on even very young babies. Babies' auras are very delicate and they need to adjust gently to being here and to their surroundings. We should consider keeping our babies in white for as long as we can and because the fontanelle at the top of the head stays open for quite a while, we need to be thoughtful about what colour bonnets and hats we put on their heads. The first nine months are important for their readjustment and for bonding and the awareness and development of their senses. The nine months in the womb and the first nine months of life equal 18, and when we bring this down to single numbers (1+8) we get nine, the number of gold and completion.

Today, many paediatricians agree on the importance of the first nine months of life for the baby's future emotional, mental and physical development. Babies can be over-stimulated by too much colour energy too early on, especially in the room where they sleep. The nursery should be an oasis of calm – a womb with a view.

A baby's first experience of colour begins in the womb. As light permeates the mother's skin, the baby is bathed in a warm peachy pink – the colour of unconditional love. This is the ideal colour for the nursery walls, with soft powder blue, sky blue or soft lilac picked out in small areas and the furnishings. Choose white, cream, ivory or buttery white for the paintwork. A warm soft glow of peachy pink is the perfect choice for lampshades as these colours create a feeling of unconditional love and contentment for mother and baby. For cot covers and duvets, choose pale pastel colours with a subtle delicate design and put your baby in white night suits and white sheets.

Soothing techniques
• • • • • • • • • • • •

To bring immediate relief to a baby suffering from colic and help to release trapped wind:
• Measure 4fl oz of freshly boiled water that has been cooled into the baby's sterilised bottle and secure the top with a plastic screw-on lid.
• Wrap some indigo gel around the bottle and secure with an elastic band.
• Stand the bottle on the windowsill in sunlight or daylight for 15 minutes.
• Remove cover, replace teat and offer the baby a drink of the energised water.

For cradle cap, massage the baby's head with a small amount of violet energised oil:
• Take a small glass bottle of sweet almond oil and remove all labelling.
• Wrap the violet gel around the bottle and secure with an elastic band.
• Stand the bottle in full natural daylight for 30 minutes.
• Pour a small amount of oil into your palm and gently massage the violet energised oil into the baby's scalp.
• Leave on the scalp for one hour before shampooing.

To relieve nappy rash:
• Prepare the violet oil as above.
• Massage the oil into the baby's skin, keeping it away from his or her hands (as babies and small children can easily transfer the oil from their hands into their eyes, where it will cause discomfort).

To relieve fever and lower a temperature:
• Prepare indigo energised water as above.
• Transfer 2fl oz into a glass bowl and 2fl oz into the baby's bottle.
• Soak a soft, clean cloth in the glass bowl.
• Squeeze out the excess water and then wipe the baby's brow, back, chest and feet with the cloth.
• Return the cloth to the bowl and repeat the process for two minutes.
• Once you have swabbed the baby offer him or her a drink from the bottle.
• Return to swabbing for a further 2 minutes.

To settle a restless baby:
• Energise 4fl oz of cooled boiled water with the pink gel for 30 minutes.
• Offer the baby the 'pink' water immediately.
• Let the baby drink as much as possible, whatever is remaining can be consumed within the next 4 hours.

All of the above methods are just as effective with toddlers and older children. 'Pink' water will also soothe many non-specific ailments in toddlers and children that may not have an obvious external cause, i.e. a 'sore tummy' and even tantrums. Pink is wonderfully soothing and calming.

You may store coloured energised water for 24 hours in the fridge or a cool larder. The coloured oil can be stored for up to four weeks in a cool place. If you use the coloured oil daily, top up the colour treatments with the appropriate coloured gel for five minutes each day before use. Do not re-energise the original bottle of oil with more than one colour.

A special note on pets

Animals respond well to colour healing. You can use pieces of silk or cotton cloth in an animal's bedding. Use your colour knowledge when choosing their collars and coats, even their feeding bowls. A faddy eater or an animal who is fat and needs to cut down his or her food intake for health reasons can be helped with the correct colour choice of bowl. Animals' rheumatic limbs can be gently massaged daily with violet energised oil to give relief.

You can also colour energise your pets' drinking water. Place a rock crystal into a clear glass jug and cover with still mineral water. Place the jug in sunlight on a windowsill for one hour to energise the water, then remove the crystal and pour into the animal's drinking bowl.

Space clearing

Another important way in which we can affect the energy in our homes is through space clearing. When we store and hoard our possessions, we are also storing and hoarding our energy. We feel more energised and organised and rest and think more clearly when we have a good clear out and our surroundings are free of clutter. We are preparing ourselves to be on the move and be more pro-active. We are making the way clear to let the 'new' in. When we hold on to things that we do not use, we are in fact holding ourselves back energetically.

To get yourself and your life moving forwards, you need to clear

out the old energy and let the new energy in. Keep your surfaces and cupboards as uncluttered as possible and have regular clear-outs. If you don't use it, lose it! Pass old clothes and possessions on to charity shops or anyone who would appreciate what you no longer need. How many times have you taken an item of clothing out of the wardrobe, only to put it back, knowing that you'll probably never wear it again? Holding on helps us to 'hold' on to energy and not a lot moves in our lives. Let it go and create the energetic space for the new.

We all acquire too many 'things' along the way, and in the early years of a new millennium, it's an excellent time to have that clear out that you promised yourself. Make it a regular part of your schedule and not just an annual event or when moving house. Rooms, garages, sheds and gardens should be regularly cleared. When our environments are clear of clutter we feel clearer, we think clearly and our energy flows freely. We find we can make decisions easily, snap into action and become one of life's players. We are not being held back by the energy of the clutter. When we surround ourselves with clutter, we feel cluttered and find it difficult to think and act. When we hoard, we are allowing the energy to stagnate. It is surprising how much easier we breathe, move and think when our surroundings are clear and we are not loaded down by clutter. We become lighter, more active and ready for the new energy to move us forwards.

We are all affected by energy. Negative energy, caused through arguments, stress or someone feeling depressed, can build within a room or home. We sense this negative energy as heaviness in the atmosphere. This affects everyone in the building. Regularly cleanse and clear your space energetically. Here are some suggestions you can use to clear your space.

Ways to space clear

- Fire is the greatest purifier and can rapidly cleanse and clear an area. We can use the imagery of fire and flames to clear a room, a building or ourselves. Stand in the middle of the room that needs clearing and imagine red or violet flames engulfing the room, cleansing and purifying the space. If you want an instant cleanse yourself, imagine standing in violet flames.

- Stand in the middle of the room. Imagine yourself in a white column of light. On each out-breath imagine the column of light expanding, cleansing and clearing the room as it does so.
- Programme a crystal (see page 95) and leave it in the room. If someone in the household is depressed, programme a crystal for their own use.
- Essential oils, flowers and plants lift the energy in any room.
- Perfumed lilies in any room act as a wonderful energetic cleanser.
- Clap around the room, paying attention to the corners.
- To move stagnant energy put on some music and dance around the room.
- Hang a silk scarf up at the window during the day and let the colour flood the room.

14

From the Heart

*In oneself lies the whole world and if
you know how to look and learn, then
the door is there and the key is in your
hand. Nobody on earth can give you the
key or open the door, except yourself.*

KRISHNAMURTI

How many people do you know who are restless and yearning to move out of their present situation, whether this be home, a job or a relationship? We are living in a time of transition and the craving for change underlies our unease with the status quo. As our awareness begins to shift, old patterns are beginning to break down and we lose our familiar points of reference. We need to let go and flow with events, not knowing the outcome but trusting in the divine purpose. We need to trust that we are being guided and have the courage to be open to the new. When we follow our hearts, we intuitively know what is right for us and we can develop at our own pace. Like the slow rising of the sun, we can grow and develop in our own good time

knowing that we are on course. If we can stay centred and focused when all around us appears to be in chaos and disorder and know that all is well, we stay in harmony. Like the sun at the centre of the solar system, be still and in your light-filled centre.

When I begin teaching a course, I always tell the students that the deeper meaning of colour will change their lives. I watch the reaction on their faces and in the eyes of some of the souls I see before me, I notice a flicker of recognition. Others appear more sceptical but whatever the reaction, I smile, knowing that a greater divine plan went into action before they even arrived. I believe there are no coincidences in life and each one of them is led to the course to reconnect and relearn. It often marks the beginning of their journey back to themselves.

We all have the capacity and potential to be a channel for healing. Love knows no boundaries and distance is immaterial. We can mentally picture someone in need, and send them the colour of our loving thoughts and imagine them well – wherever they are. The spiritual laws are exact. The recipient of our thoughts will receive the loving uplifting energy and it will be used appropriately. When we work as therapists, we need to remind ourselves that we are only a vehicle for the energies to flow through – nothing more than a pair of hands. The energies flow through us and never from us as we work with love and dedication for our clients' wellbeing. When we keep our humility and are thankful, we are able to work in this way.

We all have the capacity to be heart-centred when we work. When a mother is cradling or nursing a sick child, she is also pouring healing energy into that child. The transmission of love is the greatest healer and the most vital ingredient for a child's wellbeing and a speedy recovery.

Every time you use colour consciously for the highest good of yourself and others, numerous doorways will be opened as you reach more deeply into the wonderful world of colour. You begin a never-ending colourful journey that holds many magical discoveries and benefits. As you become more versed in using colour, you will instantly know what colour is right for you, whatever the situation or occasion. Working with colour enables you to develop your intuition and become more in tune with yourself and the coloured cosmic energies surrounding you. It is your priceless pearl. As you listen to

the inner voice of your heart, you continually expand your awareness, perception, knowledge and understanding.

If you seek guidance, listen with your heart and work with the answers with the highest intent, you will always be in the right place and do what's right for you. Novelist H.G. Wells wrote that the fundamentals of all religions are the same, and so few that they could be written on a postcard.

Working from and through the heart with love is the key. You may need to look within, but if you search you'll find an answer to every question. Do you resonate with the answer? Does it feel right for you? Think with your heart, live in truth, and wisdom will be yours.

By working with light and colour our reverence for life grows, as does our understanding that all energy circulates and returns to its starting point. We are energy; our thoughts and words are energy and what we give out returns. The power of the circle returns us to the source. We become one with nature, the universe and each other.

Afterword

Every step and every hurdle that you cross as you travel through life opens the way for new possibilities that are not always obvious at the time. Every experience, no matter how difficult it may seem, will lead you positively further along the path to your ultimate destination. I trust your study of colour will be continuous, colour will support you in discovering the inner you and assist you in gaining deeper insights from your colour experiences. Follow the exercises in the book for profound and positive results and experience the transformation of your life through colour.

As you practise and work with colour on a daily basis you will notice your awareness of colour changes, every colour you see will become brighter and more vibrant, especially the colours in nature. You will notice many different changes on many levels in yourself and your outlook, like being more understanding to family and friends, listening more, becoming more aware of your environment and what is around you, even the food you eat will taste different as your taste buds change, colour will change your whole experience of life in a very positive way.

I love teaching the subject I am passionate about, I knew from the very first time I stood before a class that this was what I had been

searching for all of my life. To be a part of a greater plan that opened each individual to self-discovery and the full realisation of their own knowledge, made my heart sing. To witness the changes and growth in each one as they became 'lighter and more colourful' gave me the greatest pleasure.

My inner calling became so loud, even I couldn't ignore it any longer. I knew my trip to South Africa was close-the time was right. Then events manifested themselves and my calling became a reality. Things moved fast and invitations to hold workshops in Durban and Cape Town arrived. Before I knew it, I was winging my way to Africa. As soon as I touched South African soil an electrical charge shot through my body, the beauty and majesty of the country lends itself towards developing the higher self. South Africa truly is one of the major heart centres of the world. The natural beauty is breathtaking and the spiritual energy emanating from her land is awesome. People threw open their hearts and homes to me and I formed lifelong connections and friendships that time that partings or distance will never erase.

On my return to the UK I knew subtle shifts had taken place. I carried on with my work and in my quiet moments I noticed that a different message was coming through. Eagles, bears, elks, mountain lions and turtles to name but a few, appeared vividly before me in stunningly clear images. I could see every hair and every feather. This was a new experience and I had no idea why I was being shown these animals. On one particular occasion, while meditating, I experienced soaring through the air with a large eagle beside me. As we flew together, he came closer and closer and then we suddenly merged, taking me on to greater heights, soaring and dipping. I flew until I came to the shores of a hot country with white sands and palm tress gently blowing. As I circled I noticed a giant turtle basking in the sun and then watched it move into the turquoise blue sea. When it was time to come back and just before I opened my eyes, I heard the words 'Black Elk, little one, Black Elk'.

I was puzzled as to what it might mean. My answer came before too long. I found that my group work was taking a distinct native American slant. Even though this was 'new' ground for me, it felt comfortable and right. It was at this time, that I was sent a tape containing one of my favourite songs 'Eagle I call you'. We play this

song at the bonfire ceremony on the colour courses and every time I play it, memories of my 'flight' come rushing back.

My life so far has been a wonderful colourful journey. My colour work has taken me around the UK and overseas. How blessed I am to be following my heart and to be doing the work that I love so passionately. Life is a wonderful, colourful adventure for us all, full of learning curves and character building moments, and there to help us, support us, illuminate and to navigate us on our journey, the divine management is forever lovingly and patiently waiting in the wings, waiting for us to ask, and every colour in nature, calls out to remind us of our way home ...

Colour Appendix

Below you will find the colour index. The list under each colour shows that each one has its own special gifts as well as its shadow side. It is important to recognise the shadow side – like receiving and giving they are opposite energies that are inextricably linked. Giving and receiving can be understood by comparing it to the act of breathing: inhaling and exhaling. If we don't exhale we will be unable to inhale, similarly if we give out too much we will exhaust ourselves. Receiving seems to be the stumbling block for many of us; we seem to view giving as expected and receiving as selfish.

Consult the colour index and make an honest appraisal of where you are at the moment. Are you resonating with the gifts of each colour or its shadow side? Once you recognise where you are in relation to the colours, rebalance by working with its fulfilling gifts.

Colour Index

Red – Life

Red gives us a jolt to get moving and stimulates our appetites. It arouses our desires and raises blood pressure. Red seeks attention and arrests attention. It is a powerful energy, the colour of courage, the pioneer. Red is vibrant, hot, active, strong, passionate, daring. It gives us stamina and affects our emotional responses. It's the colour of birth, life and death – in fact it is the essence of life, the colour of blood. Red stimulates and is wilful, has determination, is spontaneous.

Dynamic, primal, strong, forceful, survivor, determined, sexual, ardent, persistent.

Restless, bores easily, can be ruthless, argumentative, quick to lose temper, a hot head.

Orange – Health

Orange awakens our inner potential, sparks our creativity, makes us confident and urges us to communicate our inner feelings. The colour of health, humour, joy vitality and play, orange liberates us and is the most sociable colour of the spectrum. It helps us to bring to fruition our inner potential, to manifest our vision. It is the colour of laughter and a love of life. Orange is also the colour of relations and relationships.

Active, sharing, constructive, together, sociable, full of gaiety, extrovert, exhibitionist.

Can lean on others, proud, despondent, lazy, destructive.

Yellow – Intellect

The colour of the sun and springtime. Mostly associated with the mind, yellow is warm and expansive and opens us up to new ideas. The colour of clarity, awareness and alertness, too. Yellow knows no boundaries and too much can over-stimulate. Yellow can be the colour of the coward and the controller but it is also the colour of optimism, the broadminded seeker, the colour of memory and mental agility.

Bursts of energy, war, expansive, alert, cheerful, confident, optimistic.

Critical, sarcastic, exaggerates, shrewd, devious.

Green – Harmony

Green, neither warm nor cool, is the great regulator found in the middle of the spectrum. It harmonises and balances, is adaptable, open, compassionate, and humanitarian. Green is the colour of abundance, the safe colour of nature, serene freedom and hope. It is the colour of mediation, adaptability, calm, relaxation, empathy, the colour of the heart centre.

Open-hearted, open house, decisive, peaceful, nature lover, needs freedom.
Spendthrift, envious, restless, jealous, possessive.

Sky Blue – Communication

The colour of the sea and sky, expansive lively blue, colour of self-expression, trust and healing. The most popular colour, it can be peaceful, serene and sedating. Sky blue calms, soothes and cools. It is the colour of honesty, truth and belief in higher ideals.

Blue, however, can make us aloof: we need the warm colours from the magnetic end of the spectrum if we are feeling blue.

Keeps their head when all around are losing theirs, love of beauty, psychic, adaptable, protective, loyal.
Can talk too much, be fearful and restless, self-centred.

Indigo – Integrity

The colour of the night sky, understanding, and devotion to high ideals. Indigo is orderly, inspired and the colour most associated with intuition. The colour of the higher mind, it can be used with either orange or pink to bring up and release fears. Indigo can fortify and strengthen our resolve and give us the determination to proceed, with clear, focused thought.

Brave, courageous, decisive.
Impractical, needs to socialise, scattered thoughts, inconsiderate, fearful.

Violet – Higher Consciousness

Violet inspires the artist to give of their best. It is the noble colour of purpose and spirituality. With violet we keep our feet on the ground and reach for the stars. It is the colour of loyalty and dedication to

high ideals, enlightenment and service for the good of all. Violet has the fastest vibration and is totally efficient as a space clearer.

Clear thinking, understanding, focused, purposeful, high ideals, inspiring, powerful.
Superior, dogmatic, abuses power, depressive, can be morbid.

Magenta – Respect

Magenta is spiritually uplifting and will demand and give respect. Magentas experience a connectedness to the earth, coupled with an intense spiritual awareness. Magenta is inspired, ambitious and fearless. Magenta releases us from past conditioning and anything that may hold us back. Magenta stimulates us to rebalance our emotions. It is the colour of spiritual knowledge combined with earthly wisdom. Magenta recalls and rediscovers.

High ideals, organised, protective and mature.
Snobby, arrogant, flaunts power, hidden anger, domineering.

Black – Surrender

Black can be our great rebirth and the beginning of new ways. It gives us moments of escape – to think again of which way we can go. Revival and renewal comes from times of reflection. When we close our eyes the first colour we all see and experience is the hush of black before any other colours or images are seen. Black holds the potential of what can be. We enter into the solitude of black to find within the beginnings of new ways. Black's message is to surrender, be still, go within and reflect – just be. Black is our springboard, we catapult from black into our new direction.

Solid, protective, the colour of being.
Black moods, despair.

White – Illumination

White contains all the colours of the spectrum, it nourishes purity and reflects all colours. White mirrors back to us what we are. It gives us clarity, makes things as clear as crystal, illuminates our thoughts – giving us the very best 'new' ideas and 'light' inspiration. White helps to bring in the qualities of all-knowing and all-seeing. It is the colour of perfection and also the dove of peace.

Innovative, open-minded, fair, a natural leader, steadfast, loyal,

peacemaker, ease of being, a clear canvas to paint upon, unifies, inspires others.
Inflexible, too much of a perfectionist.

Pink – Love

Encourages feelings of unconditional love, forgiveness and tenderness. Pink dispels anger and takes the heat out of confrontational situations. Pink is a muscle relaxant, it soothes and calms, encouraging feelings of love and nurturing. Pink governs a strong and deep sense of right and wrong, it is the voice of your heart and your conscience.
Patient, loving, kind, nurturing, soothing.
Easily hurt, tendency to be overwhelmed.

Gold – Completion

Gold is the highest known vibration and signifies the highest wisdom and knowledge. Gold has no shadow and is the one colour that we need to earn for it to stay in our aura. We instinctively understand the preciousness of gold as we hold it in such high regard. Gold is the pinnacle, a recognition of our spiritual achievements, earned through many lifetimes. It is about giving oneself to service of the most high, total fulfilment, total acceptance, spiritual abundance, the bliss of true knowing. In gold we have completed our cycle, and earned the spiritual recognition our efforts deserve.
Gold is completion.

June McLeod – author, business consultant and teacher
The first in the world to work in circles of colour within the colour therapy arena.

Colour is her passion.With an enviable list of blue chip international clients, she is recognised as the most respected and loved colour expert in the Uk today. June endorsed the first colour therapy paint range in the Uk, she can be contacted via her website. www.junemcleod.com

June McLeod is the founder of *Colours of the Soul* colour therapy training courses, comprehensive certificated and diploma courses on colour.

June is a pioneer in her field of expertise, always encouraging her students to think out of the box. Her courses are renowned for fun laughter and her down to earth spirituality and good sens of humour. The courses are inspirational, hands-on, interactional and life changing.

The courses begin in the most exciting but unconventional way, by dancing and moving around the room to music. Music and movement play an important and large part in Junes courses clapping, stamping feet, bending knees, swinging arms – Junes unique and excellent way to ground energies, clear the environment and clear "stuff" from our energy field. The music used throughout the courses varies from classical, pop, rock or jazz! No boring name introductions here!.

Products
June McLeod holds the exclusive distribution rights to the professional silks used for colour healing, they are full body size and of the highest quality silk, being boxed and beautifully presented with full care instructions available in the full range of ten colours.

Colour music CDs, colour posters, colour filters to solarise water and oil and the coloured lights for the professional therapist.

Index

O

is a symbol of the world,
of oneness and unity. O Books
explores the many paths of whole-
ness and spiritual understanding which
different traditions have developed down
the ages. It aims to bring this knowledge in
accessible form, to a general readership, pro-
viding practical spirituality to today's seekers.

For the full list of over 200 titles covering:
ACADEMIC/THEOLOGY • ANGELS • ASTROLOGY/
NUMEROLOGY • BIOGRAPHY/AUTOBIOGRAPHY
• BUDDHISM/ENLIGHTENMENT • BUSINESS/LEADERSHIP/
WISDOM • CELTIC/DRUID/PAGAN • CHANNELLING
• CHRISTIANITY; EARLY • CHRISTIANITY; TRADITIONAL
• CHRISTIANITY; PROGRESSIVE • CHRISTIANITY;
DEVOTIONAL • CHILDREN'S SPIRITUALITY • CHILDREN'S
BIBLE STORIES • CHILDREN'S BOARD/NOVELTY • CREATIVE
SPIRITUALITY • CURRENT AFFAIRS/RELIGIOUS • ECONOMY/
POLITICS/SUSTAINABILITY • ENVIRONMENT/EARTH
• FICTION • GODDESS/FEMININE • HEALTH/FITNESS
• HEALING/REIKI • HINDUISM/ADVAITA/VEDANTA
• HISTORY/ARCHAEOLOGY • HOLISTIC SPIRITUALITY
• INTERFAITH/ECUMENICAL • ISLAM/SUFISM
• JUDAISM/CHRISTIANITY • MEDITATION/PRAYER
• MYSTERY/PARANORMAL • MYSTICISM • MYTHS
• POETRY • RELATIONSHIPS/LOVE • RELIGION/
PHILOSOPHY • SCHOOL TITLES • SCIENCE/
RELIGION • SELF-HELP/PSYCHOLOGY
• SPIRITUAL SEARCH • WORLD
RELIGIONS/SCRIPTURES • YOGA

**Please visit our website,
www.O-books.net**